Jane and Louise Wilson

Jane and Louise Wilson: A Free and Anonymous Monument

Film and Video Umbrella

BALTIC / Centre for Contemporary Art

Lisson Gallery

Foreword

A Free and Anonymous Monument already feels like something of a landmark in the development of Jane and Louise Wilson's film and video work. Not only their largest installation to date (encompassing thirteen separate projections and unfolding over 700 square metres of floor space), it is also their most ambitious and adventurous. A kaleidoscopic tour-de-force that situates their trademark explorations of place and space in an expanded architectural/sculptural setting, it conjures up a unique and unprecedented hybrid of visual art, architecture and film.

If the piece constitutes a step into the unknown, it is also a kind of homecoming. Filmed, mostly, within a twenty mile radius of the area of Newcastle-upon-Tyne where the artists grew up, it casts an enquiring and ambivalent eye over the rapid but piecemeal regeneration of this part of the North East of England, a former industrial heartland, which, like a number of equivalent cities across the globe, is now rushing to divest itself of many of the remnants of its recent past and hitch its prospects to the star of technological innovation. As the focus of production shifts from ship manufacture to chip manufacture, from the soot and grime of heavy industry to the dust-free assembly lines of new electronics and communications companies, the Wilsons capture the sense of an urban landscape in flux, gripped by the rhetoric of hi-tech renewal but equally shadowed and haunted by the architectural hulks of times, and futures, past.

At the heart of the installation is one, now largely forgotten, relic of an earlier phase of post-war regeneration, Victor Pasmore's Apollo Pavilion, built in 1958 in the nearby new town of Peterlee. An unlikely architectural experiment, whose radical utopian credentials were embodied in its stark and uncompromising lines and in its choice of the then state-of-the-art material of reinforced concrete, it now lies beached and stranded, out of place and out of time. For Jane and Louise Wilson, however, this outpost of architectural modernism still exerts a powerful fascination. Half a century on, though suffering from increasing dilapidation and neglect, the pavilion still has a remarkable presence – as singular, as idiosyncratic and as visionary as the decision to allow a visual artist like Pasmore to design and build it in the first place.

A fitting subject for Jane and Louise's Wilson's roving camera, Pasmore's pavilion also acts as a blueprint for the work itself. Taking its template of free-floating planes as the physical framework for the installation, *A Free and Anonymous Monument* turns the outline of the pavilion into a fractured panorama that brims with movement, space and light. Anchored at either end with two enormous slabs of concrete, the work possesses an undeniable, even monumental, weight and scale. Yet, for all its impressive size and scope, what is arguably just as striking is its multiform quality, its refusal of fixity. A matrix of proliferating pathways and multiple perspectives, the installation radiates a feeling of mobility and transformation, a spirit of modernity and discontinuity, that not only mirrors much of Pasmore's original aesthetic thinking but, increasingly, finds a wider echo in a contemporary post-industrial zeitgeist marked by technological change and dematerialisation; where all that was once solid now melts into air.

A Free and Anonymous Monument is the result of a close collaboration between Film and Video Umbrella and BALTIC Centre for Contemporary Art in Gateshead – itself a prime-mover in the recent renaissance of Tyneside as a 21st century cultural capital. Although the piece continues a relationship between Film and Video Umbrella and the artists that stretches back almost a decade, BALTIC's role in the project was equally pivotal, particularly in both the development and the presentation of such a complex and challenging work. This publication benefits from additional support from both organisations, and from significant contributions from the Lisson Gallery in London and from 303 Gallery in New York. Furthering their invaluable assistance to the production of the work itself, Film London and, especially, Arts Council England, also gave generously in support of this publication. We would like to thank everyone who was involved in putting it together, and relay our special thanks to Jane and Louise Wilson for their energy, co-operation and commitment through all the various stages of this project.

Steven Bode, Director, Film and Video Umbrella
Stephen Snoddy, Director, BALTIC

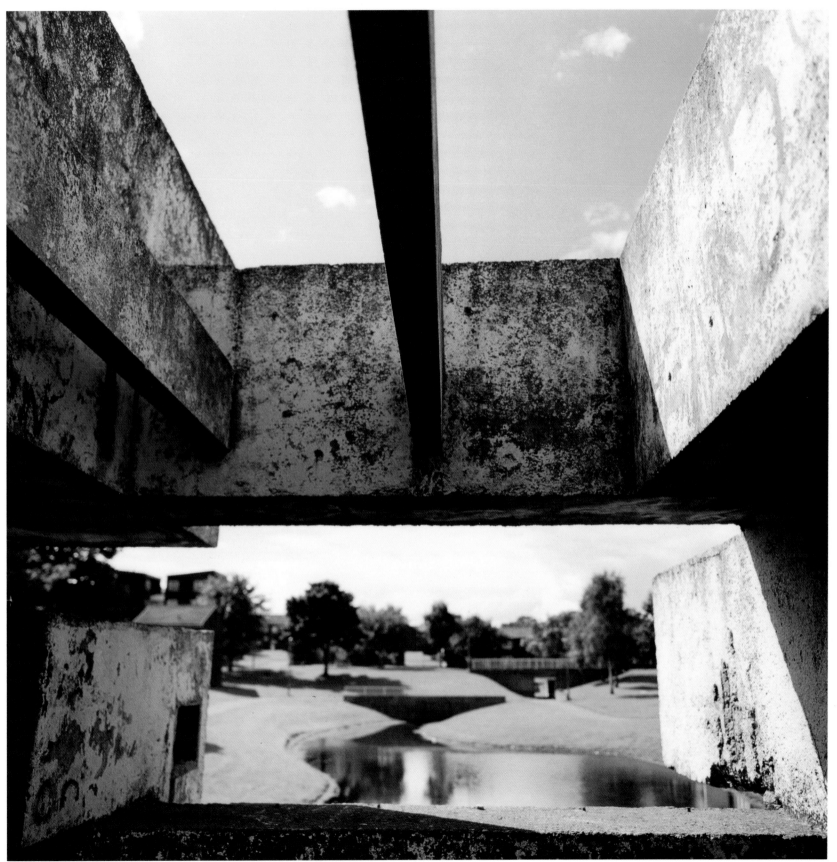

Production still: Apollo Pavilion, Peterlee

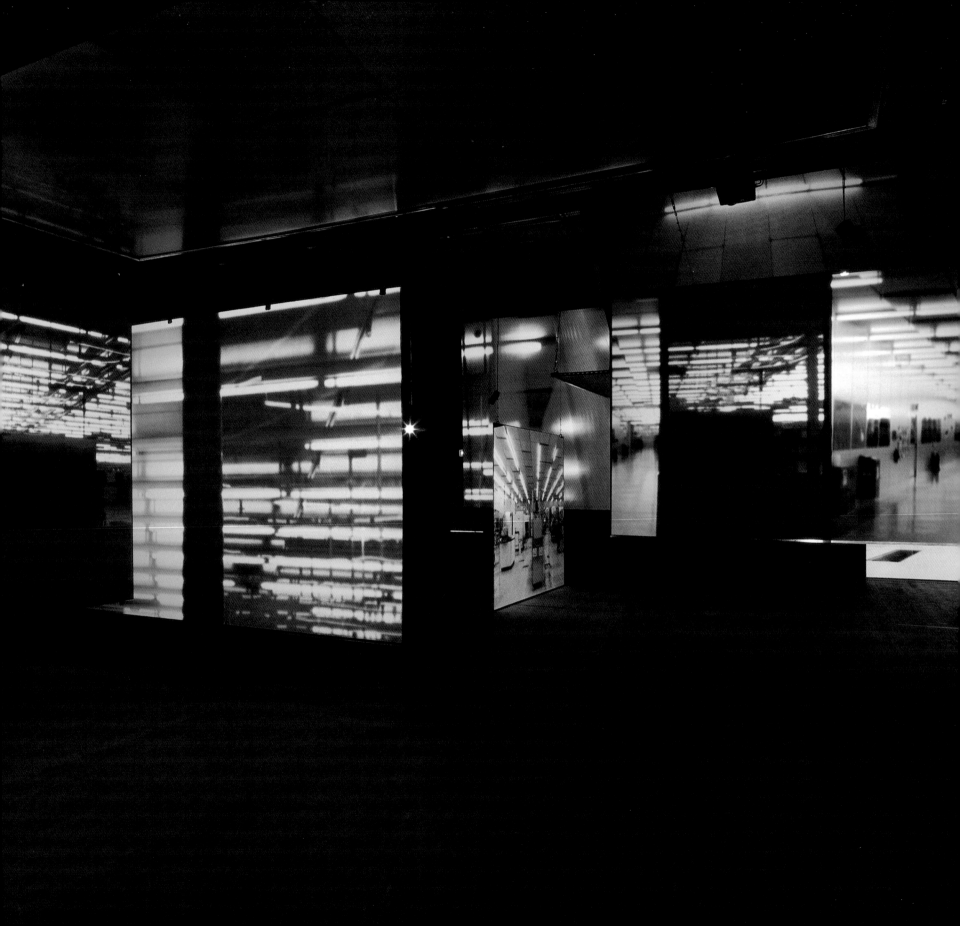

Modernist Ruins, Filmic Archaeologies
Giuliana Bruno

Artist and architect speak the same language… Urban environment is an artificial landscape so the process of constructing it is not unlike making a pictorial composition through which you move imaginatively; along the road, down the path, through the trees, round the corner, over the hill… Space is a function of feeling.
Victor Pasmore

You walk into the space. An architectural remnant stands there. It frames the space, both literally and metaphorically, giving it perspective. The mental geometry of the work is all there. All you have to do is yield to it. And so you enter this large frame, sensing a tectonic concrete surface. The frame soon presents itself as an entranceway and becomes a liminal passageway. There is a long suspended wall above your head that leads you inside a space. You walk beneath this structure, allowing it to guide you, as if preparing you for a walk-through experience.

At your own pace you advance toward other kinds of architectural remnants. The walls you now face are moving. In fact, they are made of moving images. They are walls of light and screens of motion. The thirteen separate, projecting planes, creating two chambers of vision, are oriented in divergent directions. Disjoined, they come at you from different angles, are reflected on the floor, and even hover over you from above. On the sheer surfaces of the variously positioned screens you see a veritable pandemic of images. They are projected simultaneously, on all those screen-walls, from all the different angles of vision. Images shot in industrial and post-industrial sites are presented in looped sequences, and as you watch these light planes exploding with images, you are mesmerised. You walk, stand, stare, and walk again, and become totally immersed in this multifaceted visual geography. The space takes hold of you, viscerally, by the force of its audio-visual construction. Upon exiting, you encounter another suspended concrete structure that, itself functioning as a passageway, becomes a bookend for the installation.

At some level in its burgeoning complexity, beneath the pristine surface, you sense a material weariness, the force of a languid vision. Ultimately, the place exudes a lingering sense of melancholia. This kaleidoscopic space seems haunted by a memory. It is as if the space itself were a recollection, speaking of some place you, too, knew intimately.

A Monumental 'Set' of Images

Jane and Louise Wilson's multi-screen moving-image installation *A Free and Anonymous Monument* (2003) feels like an elaborate stage set. And as a set, it is a lived space, frequented by the stories that took place there, over the course of time, and bearing traces of those spatial narratives. The first 'set' of these memories is inscribed on the surface of the walls, in the very architecture that frames the space of the installation, providing both access and egress. The evocative concrete architectures we described standing at the entrance and exit are, in fact, stand-ins for a construction of the past. They are, indeed, remnants – vestiges of the Apollo Pavilion, built by the artist Victor Pasmore in Peterlee New Town, near Newcastle upon Tyne, in 1958. The suspended walls are, literally, suspended memories.

As you access the two chambers between, created by the freestanding screens, they, too, feel suspended in space. Without a frame, they do not read as pictorial but rather as architectural space. Built in such an environmental way, these screens recall a 'suspended construction' Pasmore himself made with Richard Hamilton for an exhibition of 'Environmental Painting' at the Hatton Gallery, in Newcastle, in 1956. Appropriately called *An Exhibit*, this was an environmental painting through which the viewer, turned spectator, could walk.

Following the path that Pasmore set, Jane and Louise Wilson have designed their own environmental walk-through. Their architectural journey, a reconstructed memory of Pasmore's spatial vision, is an actual construction – a mnemonic 'fabrication' that haunts the space of *A Free and Anonymous*

Monument throughout. But it is when you are immersed in the chambers of the installation, looking at the different kinds of walls – the surfaces that are screens – that you are literally inside the Pasmore memory-space. Among other images, the screens project scenes of the Apollo Pavilion. This utopian bastion of urban renewal and regeneration, now neglected, is shown in its current use, functioning as a playground for local youngsters. Its ludic use takes us back to the idea of what a pavilion was in its original architectural function. In fact, several traces of memory are inscribed in the form of the pavilion, and it is up to us, the viewers, to unravel their story.

The Fabric of Memory: The Ghost of Victor Pasmore

If memory here is actually fabricated, it is also inhabited, and Pasmore is the primary dweller of this mnemonic architecture. He is the ghost of the place, for the pavilion is not merely the object of portrayal here but a formal element of the representation, the key to unlock its vision.

The recollection of Pasmore's visual planes haunts *A Free and Anonymous Monument* in several layers – or planes – of the past. On one level, it reflects how Pasmore himself bore a trace of the past in the way he shaped his own artistic vision. After moving away from an early interest in landscape painting toward abstract art and urban design, the artist himself looked backward to an earlier time. In constructing his view of post-war modernism, he turned back to the canons of pre-war modernism in Europe, reviving and reinterpreting the rational visions, abstract forms, architectural promenades and utopian dreams of this earlier era in an effort, as he put it, to establish "an alphabet of visual sensations in abstract form."[1]

In 1955, Pasmore was asked by the general manager of the Peterlee Development Corporation to collaborate with the architects in shaping the urban design of sections of this new town near Newcastle, then under construction. He was involved in this process for more than twenty years, until 1977. In Pasmore's hands, the abstract relief form that characterised his art at the time turned into the grid of an architecture. As he put it, he reached the point where he was "able to construct an abstract relief on the scale of a town. The relief becomes an

architectural environment of great complexity which, like the interior of a building, is experienced internally; as such it takes on a subjective quality which is multi-dimensional in implication."[2]

Abstract texture and movement were joined in Pasmore's vision, for like a relief laid out environmentally, the layout of the sections of town was conceived in a dynamic fashion. The spatial conception present in Pasmore's art migrated easily into this urban planning, for both art and urban design were thought of, jointly, as practices of space. As such, they were both attuned to experiential modes of reception and careful to include in their very conception those who would make use of the space. In fact, to see Pasmore's artwork, the viewer needed to displace herself in order to grasp the subtle shifts in light and colour occurring on the projecting forms. One could even say that such a viewer, turned spectator, would activate the artwork. A maker of artworks that ask the viewer to move around in order to experience them would readily embrace town planning – which, too, is a matter of motion through space. Indeed, as Corbusier notably exemplified in his notion of an 'architectural promenade,' architecture "is appreciated while on the move, with one's feet… while walking, moving from one place to another… A true architectural promenade [offers] constantly changing views, unexpected, at times surprising."[3]

Following the trajectory of modernist architecture, then, Pasmore reinvented architecture in post-war times as a practice that engages seeing peripatetically. And thus the spatial movement that had characterised his paintings and reliefs turned into urban motions. The design of a new town became the veritable extension of Pasmore's innovative, mobile artistic vision of space.

On and Beyond Pasmore's Path

As a landscape painter one develops a sense of form and space as a mobile experience – an essential condition of urban design, and indeed of all architecture.
Victor Pasmore

8

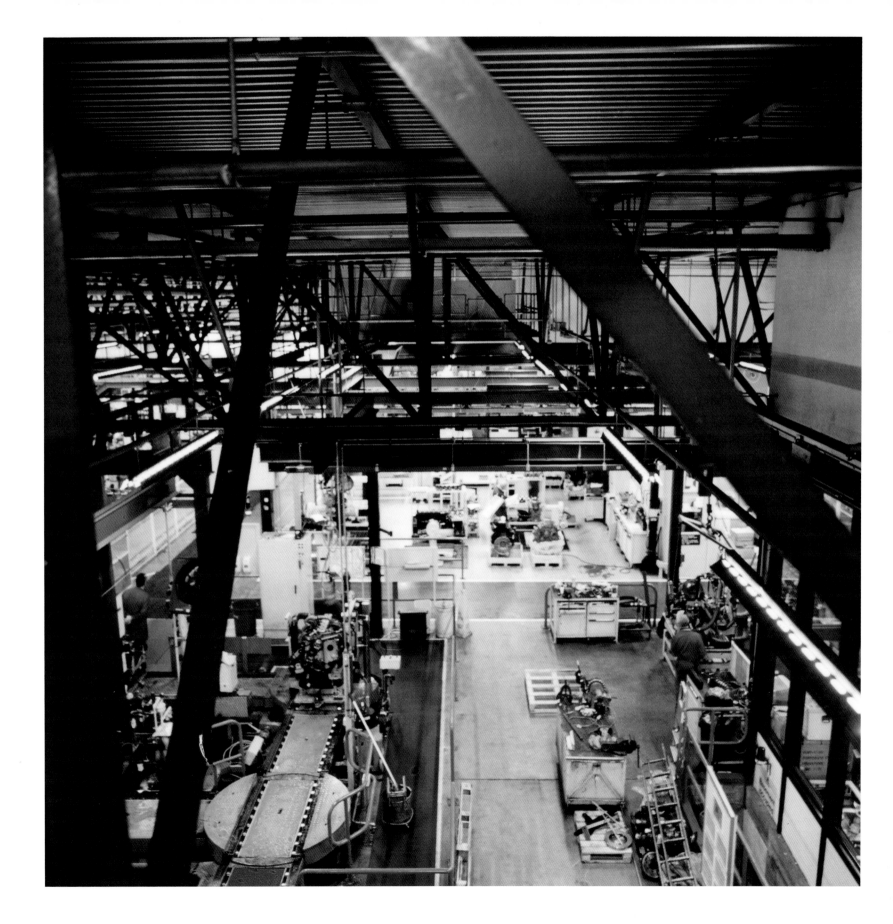

Victor Pasmore's itinerary has been influential. Through his art and design work as well as his extensive involvement in education, he carved out a path in British art that has been followed by many and is now repaved by Jane and Louise Wilson in *A Free and Anonymous Monument*.[4] Their monument to Pasmore is, indeed, faithful to the work it references: here, seeing is an activity; looking is walking. As spectators walk through the space of the installation and engage in its visual display, they activate the work. Their presence and the physical articulation of their motion design the artistic space.

Walking around the Wilsons' installation, one hears subtle echoes of the mobile design Pasmore intended for his own 'Exhibit'. You can almost overhear him say: "I imagine that I am walking or driving on the roads drawn out on my cartoon. It's a kinetic process. As you walk there, turn here, through a little passage there, out into an open space here, meet a tall building there, a gable-end here, a group of houses there."[5]

In the Wilsons' installation, space is encountered precisely this way, for the very placement of the projecting screens is conceived kinetically. Here, it is not just the images that move: the image of architecture does. The diverging directions of the screens speak of an artistic plan itself conceived in motion, and the installation's design offers more than paths to be followed. It creates a mobile architecture of vision. In such a moving way, Jane and Louise Wilson have not simply referenced Pasmore's artistic itinerary and design method; they have, in fact, 're-engineered' it.

In the process of re-engineering a mobile visual space, the Wilsons go further than Pasmore in establishing the mobility of the design process. This is especially the case in regard to the conception of the beholder of the artwork. If Pasmore's viewer, impelled to move, was made into a spectator, here the viewer is, quite literally, a spectator — a film spectator. The Wilsons' re-engineered architectural promenade is not simply kinetic but, truly, cinematic. No static contemplation is possible in this installation since the viewer is engaged in a fully mobilised audio-visual design — a filmic-architectural mobile montage.

As the viewer of the installation moves through the space, the spectacle of the images is reflected in the shadow of their reception. Silhouettes of people walking and watching animate the space. And as the gallery-goer activates the work, a narrative develops cinematically, whose plot ensues from the very act of 'being' in the space. A story, that is, emerges out of the location itself, emanating from the surface of the place — from its 'skin'. Configured as a moving construction and reflected in the form of the work's reception, the narrative is here a veritable architectural exploration. It takes its form — often a suspended shape — from the internal architecture of the spaces that are being examined, and as it develops the story is progressively moulded, suiting itself to this 'internal' architecture. It is, in other words, fully designed.

The Installation as Pavilion

As the space itself progressively tells its story in *A Free and Anonymous Monument*, a bridge is constructed. The trajectory of the installation bridges together, in form and content, the very structure of Pasmore's Apollo Pavilion, making it more than the major player in this architectural-spectatorial design but the actual matrix of the installation.

The driving force of the Wilsons' moving-image installation even takes the literal form of a bridge. In many ways, Pasmore's pavilion itself functioned in this capacity. It was conceived as a bridge over a stream and conceptualised as a moving platform from which one could view the surroundings and gather informally. The entry to the installation re-presents this idea of the passageway that opens itself to view. It even closely reconstructs the walkway of the pavilion, actually reproducing the promenade underneath the structure that one could take on the ground floor of the original.

Pasmore's pavilion was also erected as a bridge between different artistic configurations as it attempted a spatial synthesis of all the artforms. As an architecture, it was sculpturally shaped, painterly defined, and furthermore designed with a wink at the history of landscape design. The layout of *A Free and Anonymous Monument* takes up after Pasmore's design since here, too, one artform turns into another, creating a fluid relation between art and architecture.

The Apollo Pavilion was constructed of several layers of abstract forms and flat planes, which intersected to create a

sculptural third dimension for the space. In *A Free and Anonymous Monument*, the thirteen two-dimensional screens are placed around the space at angles of vision that bespeak the same pavilion architecture. The screens, that is, are designed as if they were planes of vision and positioned in such a way as to enhance the intricate layers of visual intersection present in the pavilion. They create the kind of volumetric, plastic architecture of vision that Pasmore himself strove to achieve in his design. Furthermore, the three screens placed on the ground of the installation correspond exactly to the three planes that are the concrete supports of the real-life pavilion.

Pasmore's architecture conveyed the haptic quality of the relief, a form of art that, as art historian Aloïs Riegl (1858 – 1905) noted, is appreciated by way of touch – for touch alone can reveal its formal structure and nuances.[6] *A Free and Anonymous Monument* recalls this aspect of Pasmore's abstract relief in tangible ways. With every screen placed as if it were the plane of a relief, one senses the layers and the depth of the space. One is physically engaged in its plastic density and can experience it kinaesthetically. The viewer is here led into the play of light and shadows that characterises the very architecture of the relief. Ultimately, then, the projecting planes of the Wilsons' installation can be said to 'project', phenomenologically, the architectural planes of the artist-designed building they reference.

The Pavilion, a Modern Architecture

Victor Pasmore's utopian construction was a metaphorical bridge, also, in the way it echoed past structures – the pavilion, a typical building of the early modern era – while projecting itself onto the future. In creating a monument to Pasmore's own monumental pavilion – an act reflected in the installation's very title – the Wilson twins have produced a double monument, as 'free and anonymous', to use the words Pasmore invoked for his own structure, as a pavilion itself. In order to appreciate the depth of architectural reference – a veritable theatre of memory – built into this installation-pavilion, some consideration of the architectural history of the pavilion may prove helpful at this point.

The pavilion was an important element in the design of modernity, employed most significantly in world exhibitions and fairs.[7] A large, open construction conceived to display and to house activities and movement, it presented a public use of architecture. A parent of such 19th-century venues as arcades and department stores, which were often shaped in its form, the pavilion of exhibition halls was itself a place of public 'passage' (the term for an arcade in French). A site of circulation made to display the goods produced by the industrial era, the pavilion of world expositions exemplified the very 'architecture' of the modern era.

As an architecture, the pavilion bears another set of connotations that are relevant to an understanding of the Wilsons' appropriation of this form in their installation: the heritage of landscape design in the cultural design of the modern pavilion. The pavilion was an ornamental building common in parks and public gardens. Garden pavilions were grand, light, open and semi-permanent architectural structures expanding outward toward the landscape, providing temporary shelter while embracing the outdoors. Set in a landscape, they could be used as a place of rest or retreat but also of congregation. Pavilions would dot the design of a park, punctuating the path of gardens and the movement of people through the landscape. Pavilions were also conceived as pleasure-houses, hosting such diverse social activity as spectacles, fêtes, and musical life. The name would also be given to any building appropriated for the purpose of amusement; or to a place attached to leisure activities or sporting grounds, built for the convenience of spectators.

In the modern era, the pavilion bridged the gap between the city and the garden when it became an element of urban public gardens. In its double usage, the pavilion was then, fully, a place of modern spectacle. As both display for the commerce of world expositions and quintessential architecture of garden spectacle, the pavilion was architecture made theatre. A site of public display, a place of circulation for people and goods, the pavilion was a spectacular architecture that embraced the very spectacle of modern life.

The pavilion, itself a site of exhibition, in turn exhibited the culture of modernity, for it represented the very architecture of perceptual change the era brought about. Displaying in its structure the modern vision, the pavilion

was, ultimately, a machine to see, and see differently. This light architecture was, first, an architecture of light. A trace of an outdoor space, the pavilion was open to sunlight and embodied lightness. It made for less tectonic and more agile form. As an outdoor-indoors, and an indoor open to the outdoors, such architecture broke the boundaries between exterior and interior and created a space in between. The openness of the pavilion further embodied a social inclusiveness that defied elitist, privatised spatial exclusion. Conceived as social space that was public, the pavilion reinforced the very 'sense' of public and the kinetic sensation of space made for and used by a public.

The pavilion, in fact, would gather public activity of transit from different places and draw together goods themselves travelling from afar, not only to it but also through it. In its historical trajectory, it would be joined by bridges and moving walkways, railways and steamships, elevated skyscrapers and the mobility of the means of communication. The pavilion was the architectural prototype of all those means of transport and leisure, which is to say, of the machines of mobility that characterised modernity, which housed the many different motions of social transit. This kinetic exhibitionary place 'displayed' the perceptual, cultural and social transformation of space that occurred in the modern era.

Visions of Transit, Fractured Spaces

The architecture of the pavilion exemplified the fact that in the modern era space could no longer be conceived as static and continuous. As an outcome of modernity, space has been radically mobilised and new horizons of seeing have opened up. As space was dynamically traversed by new means of transportation and communication, different perspectives were revealed and new and multiple planes of vision emerged. The perceptual field became discontinuous, shattered and fractured. As a result of this radical cultural mobilisation, our visual terrain changed in ways that are still visible, becoming what it is for us today: disjointed, split, fragmented, multiplied, mobile, transient and unstable.

The new visual landscape ensued also from the entrance of cinema into the picture. Born of modernity's mobile vision, 'motion' pictures incarnated the very geography of

modernity. Cinema displays disjointed space in motion. It introduces a language made entirely of 'cuts' and movement, of multiple and fragmented planes of vision. Cinema is moreover a quintessential public space: an inclusive place of social gathering and public transit as well as a site of spectacle. Seen in this light, motion pictures thus join the pavilion as an agent of the mobilisation of visual space – that which created us as spectators and modern subjects.

A Pavilion of Architectural Imaging

Against this background, we can fully appreciate the function of *A Free and Anonymous Monument* as complex monument – an aggregate mnemonic structure; a construction made, in many ways, of multiple levels and planes of recollection. Excavating the terrain of this 'monument' one finds various strata of architectural memory, built around the idea of the pavilion, inscribed within the stunning visual composition of the installation. Ultimately, the template of the work derives from the act of dissecting the visual architecture of the pavilion in its very history.

Pasmore's monumental revival was supposed to revitalise a post-industrial urban area, giving back to it the sense of public space. Jane and Louise Wilson's attraction in remaking a remnant of this form might be explained in part, then, by recalling this vital function of the pavilion, itself conceived as a public construction, a grand public space. The work is presented as an architecture that is to be used publicly, and one that anyone can appropriate.

Re-appropriation is the name of the game here. The memory of the pavilion's public use as the architecture of amusement and leisure is recalled as we are shown how the local youth have repossessed the dilapidated pavilion for their own use. Victor Pasmore's playful structure, itself a play on the old garden pavilion, is reactivated as young people come back there to make it a place of amusement. A free zone, a non-institutionalised meeting point, the pavilion is, once again, the site of public diversion. This involves playing with the structure itself of the building, extracting from its architecture every possible opportunity for fun, making the pavilion into an urban form of rock climbing. Poignantly, images in the

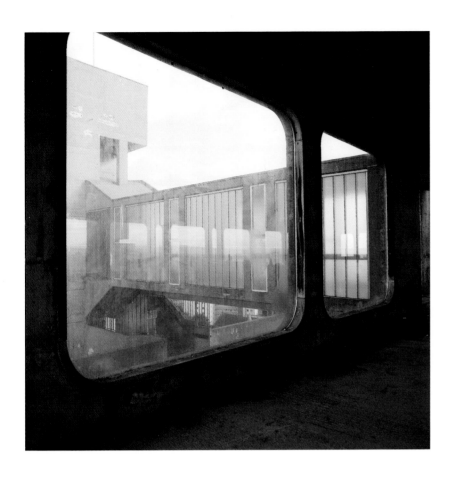

installation show us how the new users have reconceived structural elements on the side of the building as climbing platforms. This space of recreation is thus fully 'played out'.

Jane and Louise Wilson continue to play with the structure of the pavilion as they recall its function as a resting point in a garden tour and a pivot of multiple moving perspectives. The setting of the installation is composed as if drawn, precisely, on this map of modern visuality. The visual matrix generated from the architecture of the pavilion is reinvented here, however, in moving images.

In transparent ways, the Wilsons' installation formally recasts the pavilion's itinerant status as passageway while visually architecting its function as viewing platform. The installation – a multiple space of image traversal – is a permeable viewing field of circulation. Because the screens have no frame and appear suspended in space, there is clear vision across the field. The texture of the screens reinforces this openness. Indeed, the double-sided screens have the same image resolution and provide equal clarity of vision from both sides. As a result, no matter where you stand in the installation, you can see clearly. Designed this way, this is a space of light. The luminous visual zone is even pictured as a light space and embodies a further lightness of being. Again because of the open framing and the screen texture, there is no sense of being either inside or outside the picture. As with the pavilion's agile garden architecture, here there is an interior-exterior visual play. It is in this sense that *A Free and Anonymous Monument* really mirrors the visual design of the pavilion – a light architecture of light.

A plane on which to walk, and walk through, the space of the installation redesigns the garden path in that it offers 'picturesque' planes of vision. Looking at the multifaceted design of the installation, one is reminded of how one would see differently as one walked through a garden dotted with pavilions. The picture would change, seamlessly, as one progressed in the space, offering the spectator different views and panoramas. These were truly different 'perspectives'. Here, the same effect is achieved as our motion in the multiform space recreates the multivalent perspectives of a complex visual landscape. As they are drawn on the map of the installation, intensely different visual planes are here literally 'pictured' in motion.

A Free and Anonymous Monument also recalls the visual status of the pavilion as a folly. It is a monument to the visual 'playfulness' of this viewing platform, set in a fluid landscape of vision. A place to view out from, the pavilion, in turn, 'projected' outward its own visual diversity. In the installation, as if to enhance the pavilion effect, this special effect is reproduced as moving images present themselves from different angles in composite visual planarity. The visual diversity issuing from the texture of the projecting planes is also a function of the form and the shape of the screens. Each screen has a specific proportion, and all of the screens are designed in different sizes. The resulting fragmented visual space feels explosive, and mirrors enhance the kaleidoscopic effect. Three angled mirrors, set above the installation, reflect and magnify the space. A true spectacle of images thus envelops the spectator in this 'hall of mirrors'.

As *A Free and Anonymous Monument* dissects the pavilion's spectacular function as a mechanism for seeing, and seeing differently, it reminds us again how the pavilion represented not only the birth of modern spectacle but of the modern subject – what Charles Baudelaire poetically called the "passionate spectator … a kaleidoscope gifted with consciousness."[8]

In keeping with this design of modernity, the installation celebrates the multiple, fractured, disjointed, fluid and unstable nature of modern space. The design of the screens and the imagery on their surfaces together form a veritable 'exhibition' of urban culture and industrialisation. As various sites of modernity are displayed (a factory, an oil rig), we are reminded of the pavilions of exhibition halls and international expositions, with their capacity to display – 'assemble' – not only the products but the very essence of modern life.

The assemblage of the screens as shattered, moving visual planes echoes the montage of sequences shown on their surfaces. In this respect, Jane and Louise Wilson play the role of 'women with a movie camera', whose 'kino-eye' is especially tuned to the cinematic history of montage. These artists almost always shoot in film rather than video, preferring the articulation of film language and editing and the textured grain of the film image.[9] Their montage of the effects of industrialisation is not only historical in nature but shot in the tradition of

modernist cinema. Their cuts imaginatively take us from 1920s practices of montage to the bare-boned, relentless motion of structuralist cinema. Ultimately, as if recalling Sergei Eisenstein's own penchant for connecting 'montage and architecture', *A Free and Anonymous Monument* revisits, on multiple screens, this modernist, rhythmic, architectural assemblage.[10]

An Industrial Archaeology

In the Wilsons' own 'Metropolis', urban space is activated as industrial space is animated, all pulsing with the life of the machine. As if emerging out of the central pavilion – itself a *machine* of the visible – other spaces of modernity and industrialisation arise to view. Creating an assemblage of industrial zones, the artists take us on a specific regional journey, exploring sites in the area of Newcastle upon Tyne. These other sites in the region of Pasmore's urban intervention issue from the visual range of the derelict pavilion, opening themselves up to observation from this moving viewing platform.

The Wilsons' urban archaeology owes a debt to Kuleshov's notion that montage enables a 'creative geography'. The sisters' inventive industrial topography is an assembled geographic history, a chronicle that covers the whole spectrum of the industrial age, from mechanical reproduction to digital representation. In this installation, we travel from a vision of engine making and the mechanics of oil drilling to digital engineering as we move from the Cummins engine-works in Darlington to a hi-tech lab, Atmel, in North Tyneside. We journey, that is, from the inner working of actual engines to a factory that designs modern-day engines: the computer microchips that drive the machines of our technologically defined digital life.

On the same creative regional map we find the abandoned Gateshead car park, a multi-storey structure that is featured in this moving-image installation in reference to its use as a set in *Get Carter* (the 1971 film directed by Mike Hodges). Completing the post-industrial landscape, and after a return to the image of the Apollo Pavilion, we are shown an offshore oil rig, an iconic structure associated with the North Sea.

The sequence of the images on the loop (of memory) begins with shots of the Apollo Pavilion, empty. As the space is animated by the young people energetically climbing its walls, the Wilsons' artwork is activated. Because of the placement and the scale of the screens, the youths appear, in a doubling effect, actually to be climbing up the evanescent screen-walls of which the installation is composed.

In the sequence showing the Apollo Pavilion, the images displayed on the thirteen screens are each unique. This plurality of viewpoints is enhanced by the asynchronicity of the editing, with its staccato tempo, as the cuts come at different times on the different screens. Materialised here is the very visual multiplicity and fragmentation that we have seen in the architecture of the pavilion, characteristic of the montage of modern spatio-visuality. Its vision is reflected in the multiform structure of the editing: a fractured composition with a disjointed pulse. As the images of the Apollo Pavilion unfold, the rhythm itself of the installation appears composite and unstable, with visuals dancing on screens at different beats.

The form of the representation changes in the other sequences, in which the spaces are less populated. Here, the cuts happen simultaneously on all screens, creating less of a visual fragmentation and more of an expanded sense of landscape. An environmental rhythm pervades the space of the installation now, made continuous by the synchronous editing. As the images move and change rhythmically together, a mood develops. A history of industrial landscape glides across the expanded screen-space. Such history is, in many ways, a psycho-geography.

The Psychology of Architecture

> Town planning is a kinetic process of which the fulcrum point
> is interior ... Urban design ... [engages] the whole gamut of
> the human psyche.
> Victor Pasmore

In *A Free and Anonymous Monument*, spaces are acted upon, 'cut' by the kino-eye with the incisiveness that characterised the gesture of cutting into an abandoned, disused space enacted by Gordon Matta-Clark, but here reinvented cinematically.[11] Jane and Louise Wilson do not just glance at space; they delve into it,

15

kinetically accessing its interior. In their work, the inner workings of architecture are exposed.

With the inscription of their *camera-stylo*, these artists strive to create a particular design favoured by Victor Pasmore: they aim at charting the psychic makeup of an architectural space. *A Free and Anonymous Monument* extends Pasmore's understanding of architecture as psychic space and shows that artists and architects do, indeed, speak the same language when they conceive of urban and artistic environments as places through which one moves not only physically but also imaginatively. In general, as one moves through space, a constant double movement connects interior and exterior topographies.[12] The exterior landscape is transformed into an interior map – the landscape within us – as, conversely, we 'project' outward, onto the space we traverse, the motion of our own emotions. Space is, totally, a matter of feeling. It is a practice that engages psychic change in relation to movement.

Architectural design, then, engages mental design. In reconstructing this aspect of Pasmore's plan, Jane and Louise Wilson activate the geo-psychic design of architecture, following Pasmore's path closely and making use of his suggestion that urban design is a matter of 'interiors' – a kinetic process that corresponds to an internal movement. Indeed, this internal process extends to memory, and memories are themselves projected upon a space. They are traces inscribed in places. As *A Free and Anonymous Monument* attests, memories are 'architected' – designed – in motion.

In this installation we actually see the 'work' of memory. Traces of the industrialised world are here conceived as mnemonic dreams – mental architectures. The space of the installation is oneirically populated by machines. The ambiance is sparse but not pristine. Desuetude, obsolescence and entropy emerge from this mental landscape. If architecture creates mood, so does the design of this installation. Although several states of mind come to the surface of the screen, the prevalent mood, shadowed by melancholia, is never nostalgia.

We do not sense a celebration of the machine. Nor do we experience abjection in this highly mechanised landscape. The Wilsons' installation rather exudes a dark sense of solemnity. The feeling seems appropriate to its 'monumental' effort to record a history of regional industrialisation and its demise. Here the magnitude, grace and elegance of the industrial landscape strike us. As we walk through the installation, a grand sense of loneliness takes hold of us. The inner beauty of machines is revealed as the sole inhabitant of the space. Sometimes, alien-looking mechanised arms and the mechanics of the robotic are displayed in clamorous montage. Then, almost suddenly, the mood changes. In a space of absence, it is people who become robots. We enter the world of the Atmel lab, our own contemporary digital world, and glimpse at our future. Interestingly, while the noisy mechanism of making engines and drilling for oil is fully exposed to view, the images of Atmel exhibit the deceptive invisibility that distinguishes the design of our digital age.

A beautiful, bright space opens to view. This is a vast and rather barren architectural site that feels uncannily like an operating room. It is absolutely surgical. And no wonder this mood predominates here, for, as we discover, the dust-free and highly protected environment is what enables workers to 'operate' on computer chips.

The light in the space is not only striking but makes room. It creates ambiance, atmosphere and mood. We feel that we are inside the very space of light. And we can see even why: the physical process of 'etching' on a wafer requires the use of a particular, photographic type of illumination. The photo-litho process used for this digital 'engraving' is, indeed, photogenic. This yellow-lit glaring space is pure, absolute lightness.

Such luminous atmosphere has suited Jane and Louise Wilson's sensibility, which has captured a photographic lightscape and reactivated it with 'moving' images. The installation shows this light space as an energy field. Exposed here is an electric reservoir of energy: light as a force of life. The Atmel laboratory pulses with energy as the camera unveils the undercurrent of this architecture of light. As we travel through the installation we enter the lab's 'intestines'. They are quite extensive, for four floors of Atmel are used exclusively to power the one floor of the 'operation'. With such invisible mechanics built into its body, the building feels corporeal. This light space is an organism in its own right.

As we glide through the yellow-lit landscape, the sequence turns hypnotic. Space is suspended. But this suspense

is not thrilling. We rather feel a humming tension: the suspended state of lingering, hovering inside our head. We are pending, waiting, floating in mental space. A mental architecture is indeed represented here: a pensive state of mind. This is a true, 'enlightened' interior space.

In exposing this kind of inner working, the Wilsons show how completely they have appropriated Victor Pasmore's architectural lesson. For as he put it, "urban space is interior like the interior of a house."[13] Urban landscape is, indeed, a work of the mind. It is a trace of the memories, the attention, the imagination, and the affects of those inhabitant-passengers who have traversed it at different times. And that includes us, spectators of a moving-image installation. Ultimately, Jane and Louise Wilson show that moving images are the projection of our inner workings – the architecture of our minds.

Soundscape

As the composite audio-visual architecture of *A Free and Anonymous Monument* activates the spectatorial imagination, its participatory structure supersedes the usual images of control and surveillance that are associated with the machine and digital age to engage the viewer's own anonymous freedom to roam inside the work. The visual geometry of the installation defies the model of the panopticon that, in some form, generated a portion of the previous artworks the Wilsons have made.[14] In exploding all structures of control, the installation also moves beyond the symmetry of the stereoscopic vision characteristic of their earlier work. The visual metaphor for the twins' double vision is here shuttered in favour of a layered, complex architectural montage that is not only visual but aural.

In fact, the psychic architecture that is exposed here is not entirely a visual matter. The psychology of architecture is also, even primarily, a function of sound, which is an internal structure in the articulation of mental space. Here, it is engineered in the very mechanism of the installation. Each screen has a single speaker that emits its own sound. So you can move through the space of the installation following the sound cues. The sound guides you through the work, and it can direct you or misdirect you. It can make you take tours or detours. The sound ultimately locates you. And it locates the mood.

The aural environment of *A Free and Anonymous Monument* is articulated with care as a landscape of sounds is created. The installation is pervaded by specific sounds, each coming from a different location. Thus the spatial realism that arises in the installation issues not merely from the visual but from the aural structure of the work. Sound enables you not simply to locate a place but to feel the space. A variance in ambiance arises from this aural communication. We sense the different atmospheres, the various moods of a place, by the way they resound. We can actually *hear* the moods, and hear them change. Ultimately, it is sound that gives you a sense of place. Sound is the *genius loci* – the very spirit of place.

In *A Free and Anonymous Monument*, sound montage has its own spirit. Here, you traverse the whole spectrum of industrial sonority: you hear the loud sounds of mechanisation, experience the music of engineering and the quiet melody of automatism. You access the clamour and the clatter, the clang and the bang, the jangle and the rattle, the clash and the crush. Blaring, roaring, blasting noises resound tumultuously throughout the space. Then, there is a pause. You know you have reached a different zone. In contrast to the sounds of the Cummins engine works, in the Atmel lab there is an eerie stillness, a strange automatic tranquillity. You hear only zipping noises, which appear actually to flash through the quiet space. The silence is punctuated, with a cadence, by zips and beeps, by peeps and cheeps, by squeaks and clicks.

An aural choreography is set in motion in the Wilsons' installation as the sounds make a rhythm, a tempo: it rises, fades, and quiets down. This rhythmic choreography is most spectacularly conceived in the sequence of the oil rig. This is an actual symphony. All is silent for thirty seconds, before the sound comes in and fades up. The loudness of the drilling noises is contrasted with the contemplative silence of a seascape. The lonely drilling platform appears to float on the surface of the water. At sunset, it simply stands in this silenced landscape, looming over the horizon line. In the space of an aural edit, you have travelled from the energetic mechanics of Vertov to the sublimity of a Turner landscape.

In the installation, absences are sounds that, too, make rhythm. The pauses let us *listen* to the machines, not

simply hear them. They are not just making noises but are 'animated' by sound. Like humans, machines emanate internal sounds. Their noises have a distinctive character – a personality. It is as if these were thinking machines. Each tone gets us closer to their inner workings, and to the way they activate a building. As we listen carefully, we can actually access not only the mind of the building but its soul.

At some level, exposed in this sound 'installation' is a mental mechanics: the very noises in our brain. The Wilsons' symphony ranges in tone from the quietness of mind to the chatter that clouds our heads. The mood of the installation is not just varied but modulated. You can feel energised or over-whelmed by the utter clamour of mechanical engines at work. You can lose yourself in the meditative, automatic serenity of Atmel's muffled sounds. Or you can fear the absence of aural turmoil. Ultimately, it may force you to enter the silence of your mind.

Lost Sites of Power

Jane and Louise Wilson's excavation into the psychology of architecture, deep into the way it sounds, reacquaints us with a particular use of archaeology. As an archaeology of the modern, *A Free and Anonymous Monument* represents the culmination of the artists' 'sound' meditation on architectural ruins and techno-logical obsolescence. It is a mature articulation of many of the themes that have emerged in the past work of the pair, and its suspended, mnemonic design reinforces the affinity for mental architectures present in their earlier work.

Take *Stasi City* (1997) and *Gamma* (1999), for example, each of which consists of two pairs of screen projections on walls meeting at two 90-degree angles, diagonally opposite from each other. The architectural layout of these installations – two points of view shown simultaneously and bound together – mirrors a psychic architecture. This architecture of vision reveals the kind of double-vision characteristic of the bond that connects these artists, who are identical twin sisters. Conceived in a double frame, a Wilson installation is almost never a single work but most often pairs up, as happens with both *Gamma* and *Stasi City*, double works that are linked.

Gamma was shot in the former US Air Force base at Greenham Common, a Cold War operation that housed nuclear weapons and which is now a decommissioned site. The instal-lation inspects spaces of inspection and surveils control rooms and security zones, taking us off-limits into 'untouchable' spaces of power. Exhibiting the same vision, *Stasi City* was also shot in abandoned buildings. Since these buildings are the former East-German secret police headquarters in Berlin and a former Stasi prison, one might describe the work itself as interrogating places of interrogation.

In powerful and subtle ways *Stasi City* feels, as do other of the twins' works, like a set. The installation in fact restages situations that were themselves 'staged' in order to instil anxiety or fright. Figures 'hang' in the space, evoking perhaps a deadly fear of death by hanging. Or maybe they are just suspended, pending judgment – suspended, that is, in that zero gravity of lengthy bureaucratic time. The space is carefully choreographed. Devoid of human presence, with the closed doors that once imprisoned the investigated subject now pushed wide open, the 'construction' of the very space of fear is revealed. We can now see the cheapness, even the fakeness, of the psychic mechanism that was staged here – the mechanism that runs a theatre of terror.

The technique of revealing the internal mechanism of a disused architecture recurs in the work of the Wilson twins. For example, in different yet related ways, the open doors of the British House of Parliament in *Parliament* (1999) also question power this way, enabling us to get a glance at the mechanism that regulates social domination as we peer into the system of authority and legality. However, we can only be there when the place is not active, precisely because it is not functioning. Jane and Louise Wilson are endlessly attracted to places of power and control, but only when those in command have left the site. They are interested in accessing emptied, evacuated places to explore what is no longer in control there. They fancy a place out of control. Or, rather, they are interested in what happens when a place has lost control. Or, else, when a place is simply lost.

In this respect, the work of the Wilsons recalls that of another talented architectural artist, Robert Polidori. In his photographic portraits, especially in his vision of Chernobyl

and Pripyat, Polidori puts himself in the same position.[15] He, too, investigates the leftovers, picturing the ruins of power and the effects of industrialisation, and does so also with an explorative architectural eye. His camera also travels through spaces that bear traces of destruction. Redolent with the patina of time, abandoned places are shown, or rather laid bare, in Polidori's photographs – their intestines wide open to view. In many ways, his renderings of Chernobyl and Pripyat parallel the Wilsons' *Home/Office* (1998), an installation that re-presents rescued footage from London's fire brigade. Their memory loops let us into the ravages of destruction, enabling us to inhabit what are now uninhabitable spaces.

Archaeological Journeys

A Free and Anonymous Monument shares with many other works the pair has made the form of a meditation on matters of desuetude, post-industrial ruins and technological waste. In fact, these artists have long shown a predilection for visionary, 'machinic' installations – mental architectures that are barren landscapes and deserts of the mind. Take, for example, the desolate spatial layout of *Proton, Unity, Energy, Blizzard* (2000). Four screens simultaneously track the space of a Russian cosmodrome, introducing us to the engineering mechanism of a proton rocket factory. We hang in a barren hanger, visit empty offices and medical facilities. We follow a narrative sequence of telephones that no longer ring. We try to decipher signatures – traces of life – left on doors, now left 'hanging', doors no longer opening or closing for anyone. Camels inhabit the literally deserted space. As they walk away from what were launch-site towers, they lead us out of this human desert.

In a similar vein, *Dreamtime* (2001) examines the rituals of rocket launching and space travel with monumental, military solemnity. It parallels *Star City* (2000), also devoted to the once futuristic, now bygone, art of travel out-of-space. In this lost 'city', we architecturally explore the kinetic form of rockets and spaceships as the artists let us travel inside and out of off-limits space. Here, again, we are impressed by the presence of absence. Empty astronaut suits, empty dressing rooms, empty capsules and offices. Suits and rooms both voided of presence. In this way, the Wilsons' acute, observant camera connects

architecture to clothing. It equates them as spaces of the body, both inhabited by flesh. It shows what happens when bodies leave and places are evacuated of life. With the inhabitants that 'suited' these spaces now departed, only empty shells are left, melancholically drifting lifeless on screen.

Gardens of the Post-Industrial Era

Jane and Louise Wilson constantly return to what is left of a place, left out or even left over, and this return extends to the industrial landscape that makes up *A Free and Anonymous Monument*. Turning to a regional geography marked by the problems of post-industrialisation, the installation looks at a place in ruin. Ruinous is, indeed, the state of Victor Pasmore's pavilion. Once a pristine structure, a utopian monument to the idea of enacting social transformation by way of urban design, the Apollo Pavilion is now a shadow of its former self. What we see over and over again in the installation is a building that is badly maintained, dilapidated, partly dismantled, and even locked up.

In July 2000, *The Sunday Telegraph* happily announced the potential success of a campaign to demolish the Apollo Pavilion, despite its status within English Heritage as "an internationally important masterpiece." *The Telegraph* labelled the Apollo Pavilion a "concrete bungle." Less than charmed by its modernist material, the paper reported that "people around here think of it as just a heap of dirty, slimy concrete which youths climb up to have sex and urinate on passers-by."[16] Indeed, the space has been 'consummated' by the younger population's way of using the lonely concrete structure.

This never seemed to bother Victor Pasmore, who died in 1998. When the artist returned to the Newcastle region to visit Peterlee, he witnessed the murals with which he had decorated the pavilion defaced. Graffiti covered the crumbling façade of his concrete building. He was not disturbed by what others saw as a state of desolation. On the contrary, he found the graffiti to be an improvement. He mentioned that this intervention ameliorated the architecture of his building more than he himself could have done and believed this act of appropriation to have humanised the building.

A cinematic inscription of pavilion architecture, Jane and Louise Wilson's *A Free and Anonymous Monument* is a metaphoric

graffito. It is itself an act of appropriation, not only of the Apollo Pavilion as an artistic matrix but of the entirety of its post-industrial region. It is furthermore an intimate appropriation, since it is an act of love for the place of the artists' youth. It is not irrelevant that Jane and Louise Wilson were born in Newcastle, in this 19th-century centre for coal export, shipbuilding and heavy engineering, and that Jane studied at Newcastle Polytechnic. In some way, the mnemonic structure of their monument is a moving monument to their own past and to the crumbling nature of the region's post-industrial landscape.

Victor Pasmore's post-industrial pavilion made an artificial garden out of the urban industrial zone in the North East of England where Jane and Louise Wilson grew up. Its modernist design was a utopic attempt to create recreation where there was industrialisation. His restorative gesture addressed what continues to be a problem today. Urban regeneration is now a social and political issue at a global level. As artists brought up in a place that faced this issue early, the Wilsons sisters are particularly sensitive to this landscape.

In their art, Jane and Louise Wilson make continual attempts to investigate, and intervene in, sites that bear the texture of their region and of Pasmore's own site of urban intervention. Completing the collection of their previous projects of recollected landscapes, their latest venture is a work shot on location in New York, on Governor's Island.[17] An island off the coast of Manhattan, this was home not only to the Governor but also to marine, penitential and military structures. A place of residence for nearly 5,000 people who worked in those infrastructures, it is now totally evacuated of life. It is no wonder that this – the largest and most attractive site of potential urban regeneration in the New York region – has attracted the Wilsons for another filmic intervention. It is sited precisely along their path of creative, lost urban geography.

Our Modernist Ruins

The installation of *A Free and Anonymous Monument* ultimately places on exhibit Jane and Louise Wilson's relentless, recurring fascination with the ruins of modernity. Although their approach to this mental architecture is so personal and intimate here that it exudes traces of a psycho-geographic return, one can see throughout their work a personal interest in the environmental history of the aftermath of industrialisation and the Cold War, which formed them as modern artistic subjects.

With respect to a specific engagement with the vicissitudes of modern architecture, their act of re-engineering Victor Pasmore's design tackles a particular issue in the demise of modernity – the ruins of modernism. In this regard, their intervention joins that of other contemporary artists for whom the legacy of modernism is a present history to contend with. In a similar way, for example, Gabriel Orozco has taken upon himself to reconstruct Carlo Scarpa's once pristine and now crumbling 1952 modernist architecture, in a work presented at the 2003 Venice Biennale.

But what do we mean by intimately revisiting this legacy? Can we really speak of a modernist ruin? Unlike the porous, permeable stone of ancient building, the material of modernism does not 'ruin'. Concrete does not decay. It does not slowly erode and corrode, fade out or fade away. It cannot monumentally disintegrate. In some way, modernist architecture does not absorb the passing of time. Adverse to deterioration, it does not age easily, gracefully or elegantly.

Modernism, after all, had an issue with history. It was an art of the present. Modern architecture looks good in its own present. It wears itself in the now, and does not wear out. It shines when recently constructed or freshly painted. It looks at its best dressed in white. It wears only pure 'coats' of paint and pristine fashions. It looks outstanding when freshly made-up. Its façade is a face that cannot bear age marks, does not like to 'wear' them. With concrete, there no longer can be lines emerging gently on the face of a building, line drawings on the map of time past. With concrete come only cracks, the breaking up of the façade.

If the façade is a face, then the problem of modernism is skin. Modernist architecture was, after all, an architecture of the surface. This modern epidermics has the same issue with time that we do. We modern subjects, too, have an increasing issue with the deterioration of our skin. Refusing to age gracefully, we seek the radical fix. Plastic surgery is perhaps itself a measure, if not quite an invention, of modernist time and its passing. It is the sign of our times.

As we live in an age in so many ways repelled by ruination, what kind of archaeology can we now create? In answering this question, we can take one last look at Jane and Louise Wilson's archaeology, and ponder in yet one more way their fascination with post-industrial ruins. We should recognise that our history is made up of different ruins. In modern times, different architectures bear the mark of time. Time passing is not simply etched on the surface of stone. It is marked on the skin of celluloid. It is impressed on other kinds of architecture – the translucent screens of moving-image installations. Pictures in motion write our modern history. They can be the living, moving testimony of the effects of duration. Moving images are modernity's ruins. They are our kinds of monuments. A Free and Anonymous Monument.

1 Victor Pasmore, as cited in Alan Bowness, 'Introduction', Alan Bowness and Luigi Lambertini, eds., *Victor Pasmore: With a Catalogue Raisonne of Paintings, Constructions and Graphics, 1926–1979* (London: Thames and Hudson, 1980), p. 14.

2 Ibid., p. 15.

3 Le Corbusier, *Oeuvre complète*, vol. 2, ed. Willi Boesiger (Zurich: Editions Girsberger, 1964), p. 24. Here, Le Corbusier develops the idea of the architectural promenade by reading the itinerary of Villa Savoye (1929–31) in relation to the movement of Arabic architecture.

4 On post-war British art, see David Robbins, ed., *The Independent Group: Postwar Britain and the Aesthetics of Plenty* (Cambridge: MIT Press, 1990).

5 Pasmore, in 'A Symposium with Sir J. M. Richards, A. V. Williams, A.T.W. Marsden, and Victor Pasmore', Bowness and Lambertini, eds., *Victor Pasmore*, p. 261.

6 See Aloïs Riegl, *Problems of Style: Foundations for a History of Ornament* (1893), trans. Evelyn Kain (Princeton: Princeton University Press, 1993); and Riegl, *Late Roman Art Industry* (1901), trans. Rolf Winkes (Rome: Giorgio Bretschneider Editore, 1985).

7 For a general introduction to the culture of modernity, see Stephen Kern, *The Culture of Time and Space, 1880–1918* (Cambridge: Harvard University Press, 1983); Sigfried Giedion, *Space, Time, and Architecture* (Cambridge: Harvard University Press, 1962); and Giedion, *Mechanization Takes Command* (New York: Norton, 1969).

8 Charles Baudelaire, 'The Painter of Modern Life', in *The Painter of Modern Life and Other Essays* (New York: Garland, 1978), pp. 9–10.

9 I gathered this and other information on the Wilsons' working methods in interviews with the artists on Governor's Island on June 23, 2004, and in New York City on July 1, 2004. Thanks to Jane and Louise Wilson for their generous contribution.

10 Sergei M. Eisenstein, 'Montage and Architecture', *Assemblage*, no. 10 (1989), pp. 111–31. The text was written circa 1937, to be inserted in a book-length work.

11 On Gordon Matta-Clark, see Pamela M. Lee, *Objects to Be Destroyed: The Work of Gordon Matta-Clark* (Cambridge: MIT Press, 1999).

12 See Giuliana Bruno, *Atlas of Emotion: Journeys in Art, Architecture, and Film* (London and New York: Verso, 2002).

13 Pasmore, in 'A Symposium', Bowness and Lambertini, eds., *Victor Pasmore*, p. 261.

14 See, for example, *Jane and Louise Wilson*, with essays by Jeremy Millar and Claire Doherty (London: Film and Video Umbrella/ellipsis, 2000); and *Jane and Louise Wilson*, with essay by Peter Schjeldhal, dialogue with Jane and Louise Wilson and Lisa Corrin (London: Serpentine Gallery, exhibition catalogue, 1999).

15 Robert Polidori, *Zones of Exclusion: Pripyat and Chernobyl* (Göttingen: Steidl, 2003).

16 Nigel Burnham, *The Sunday Telegraph*, July 16, 2000.

17 This is a project of the Public Art Fund, New York.

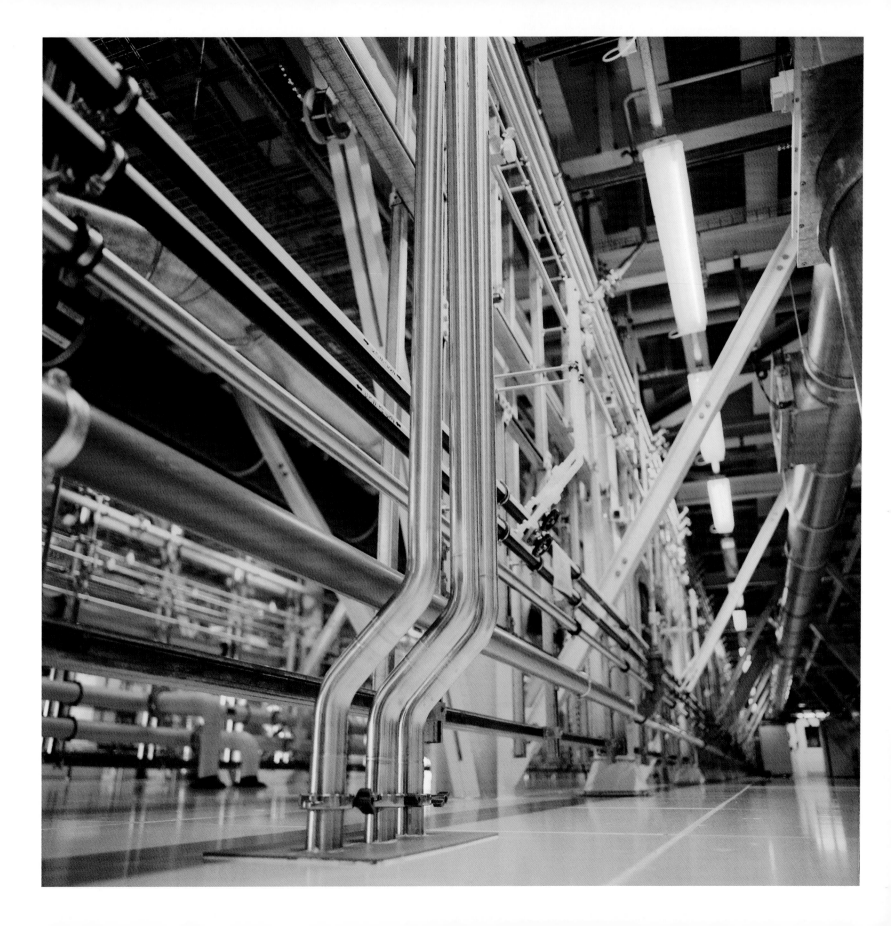

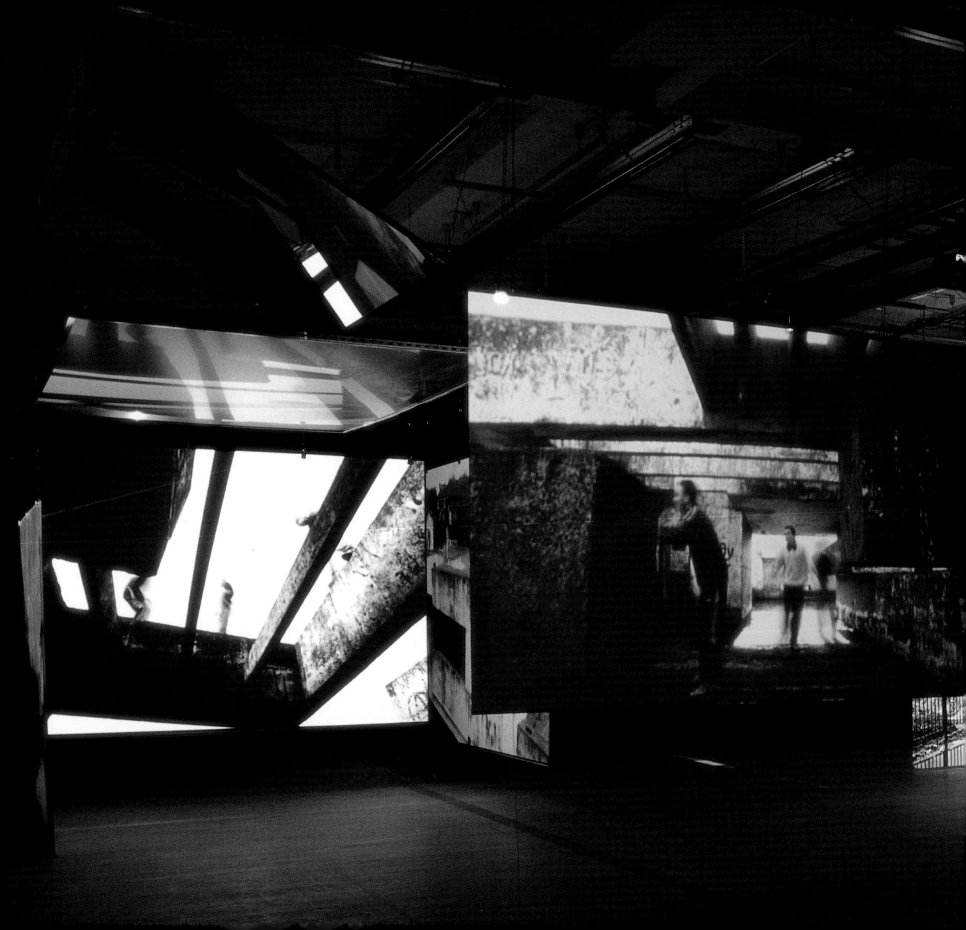

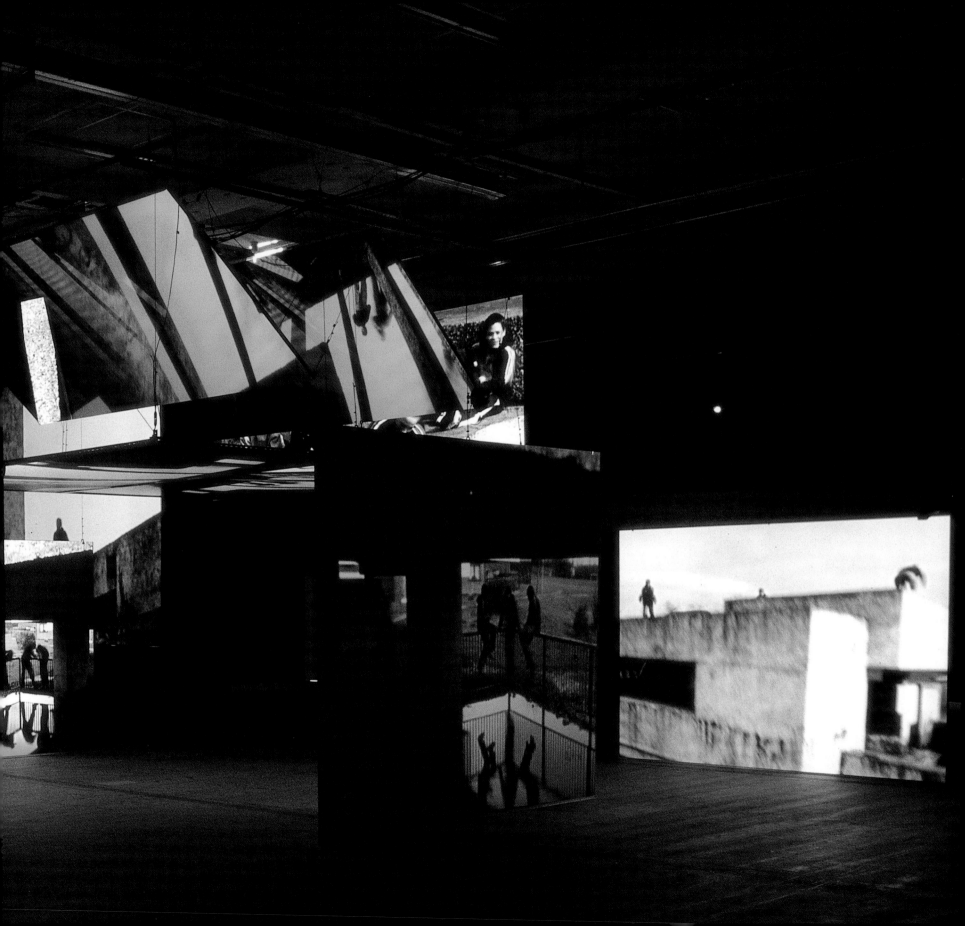

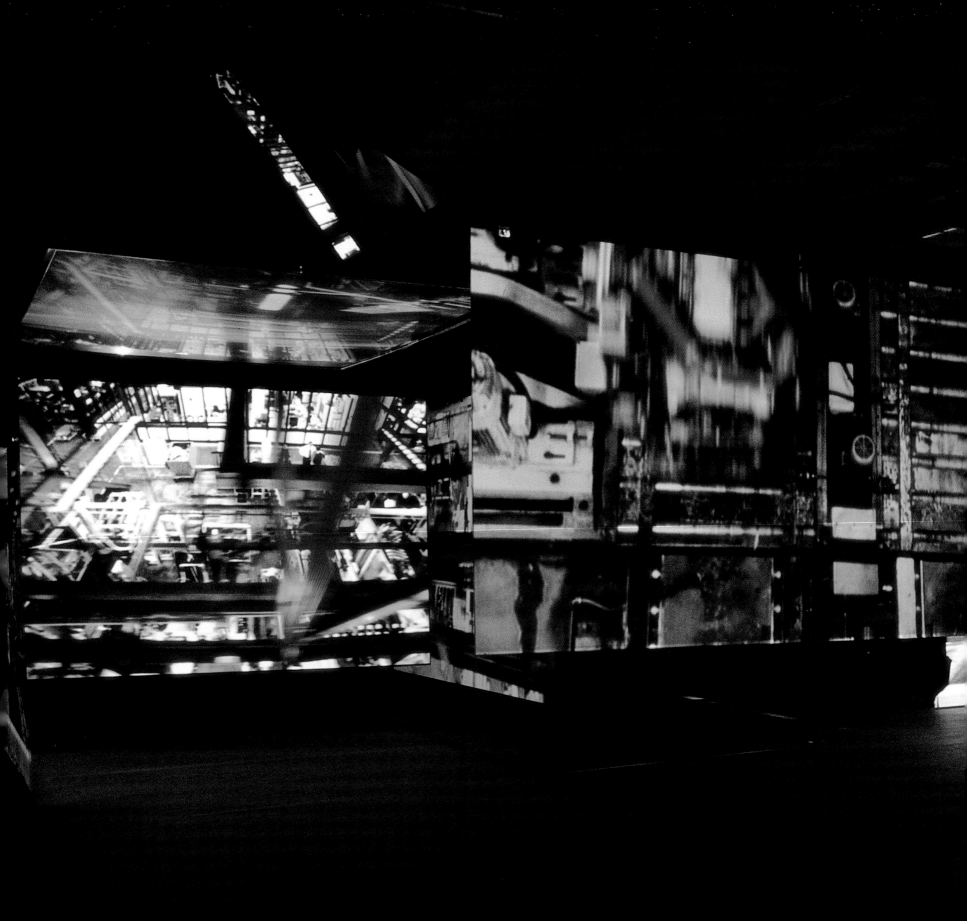

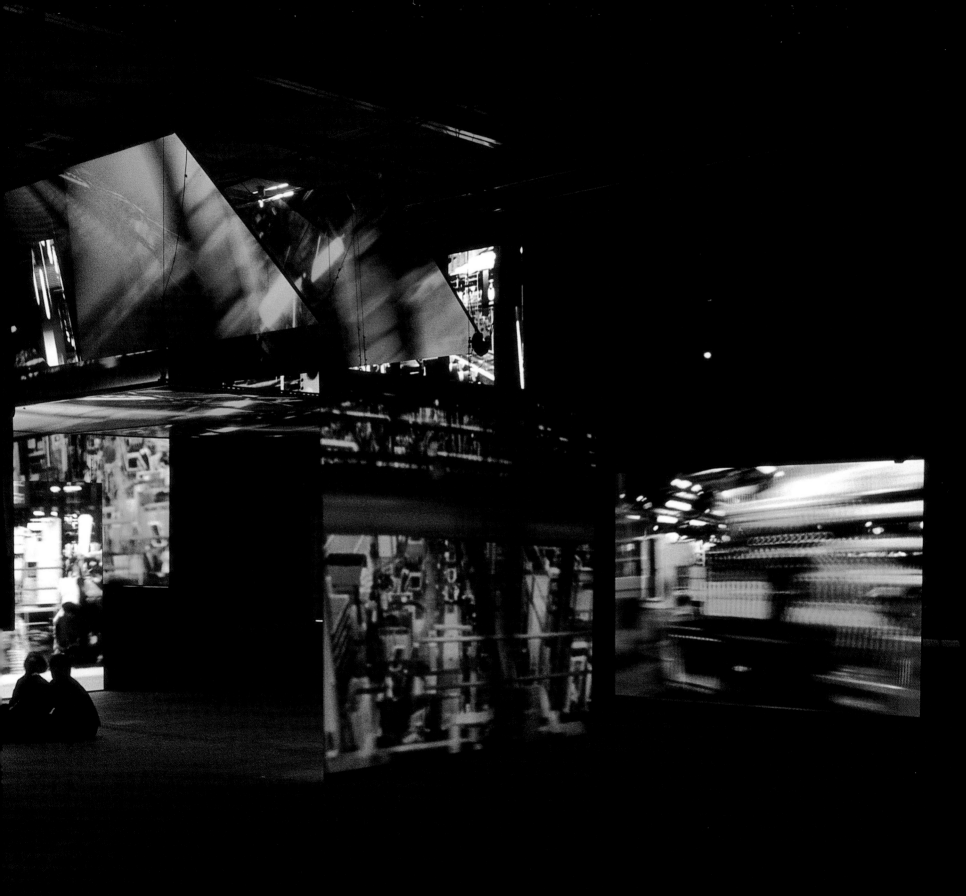

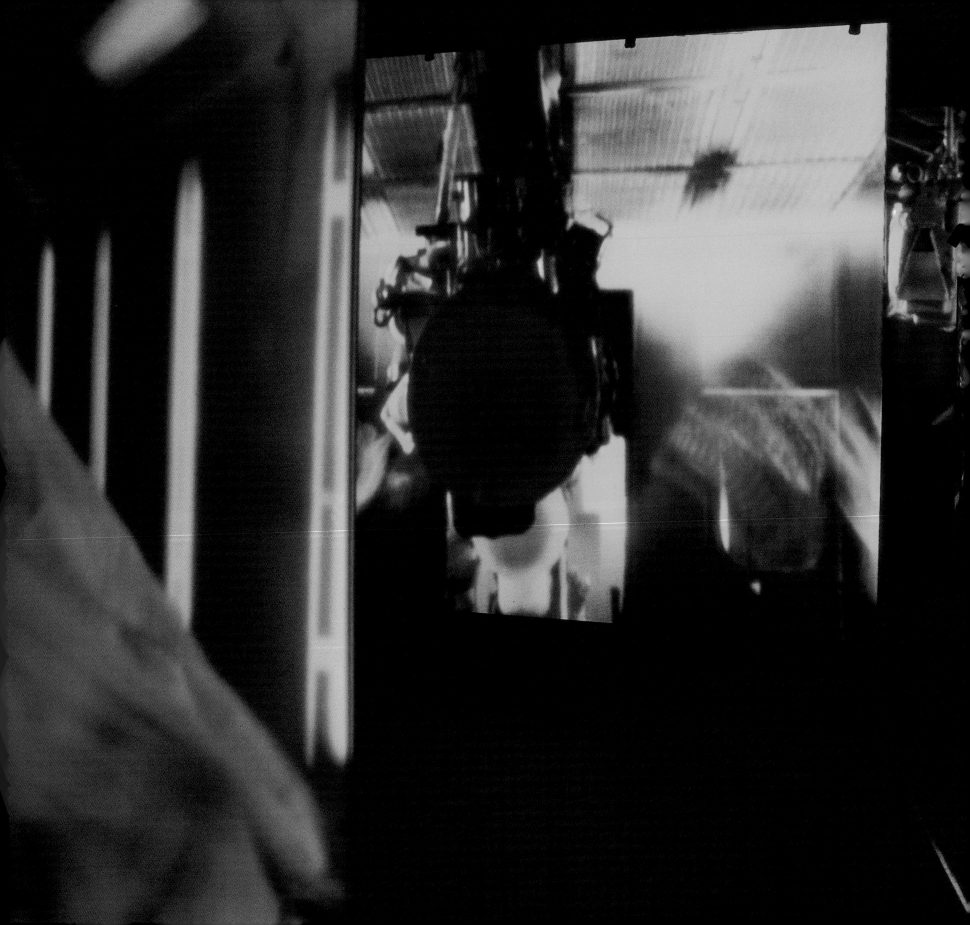

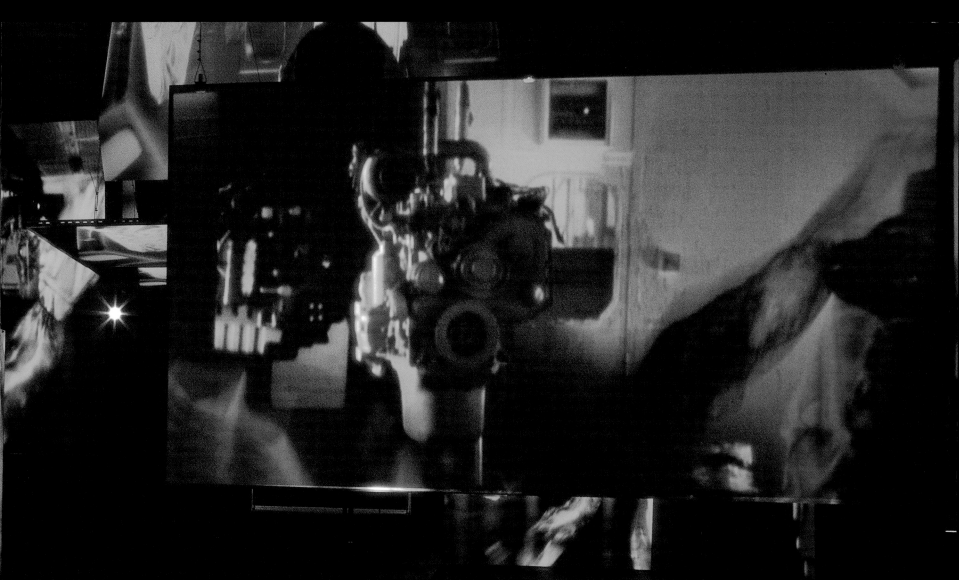

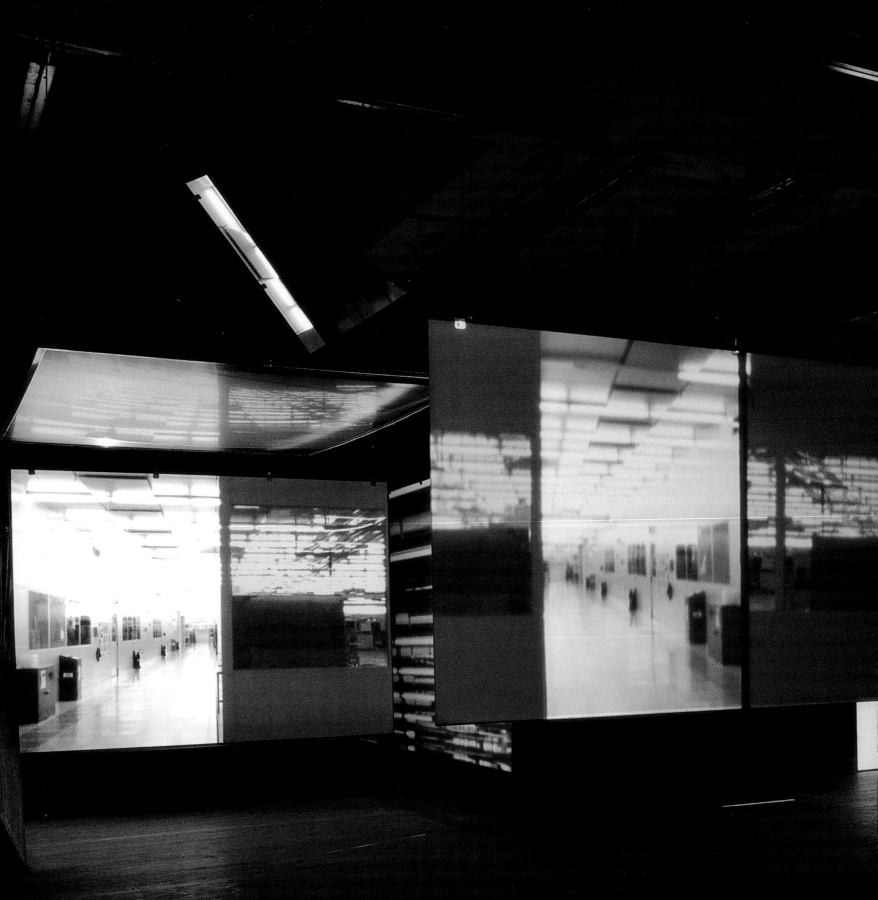

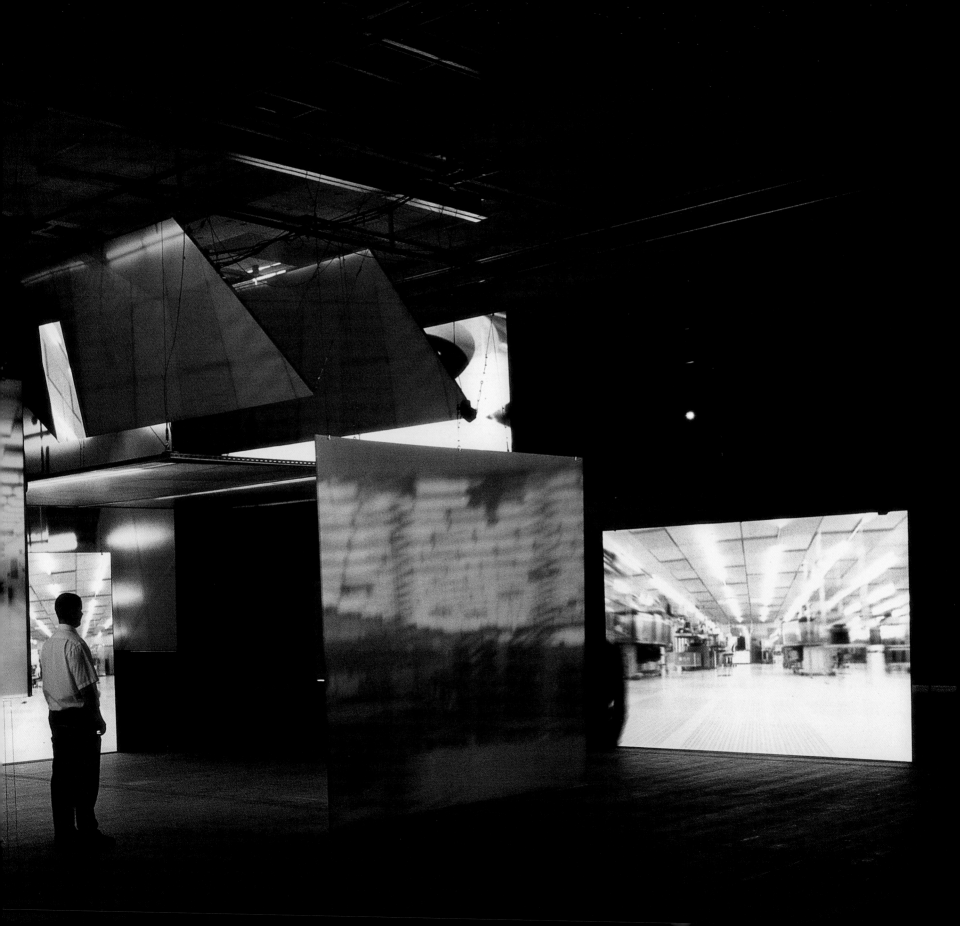

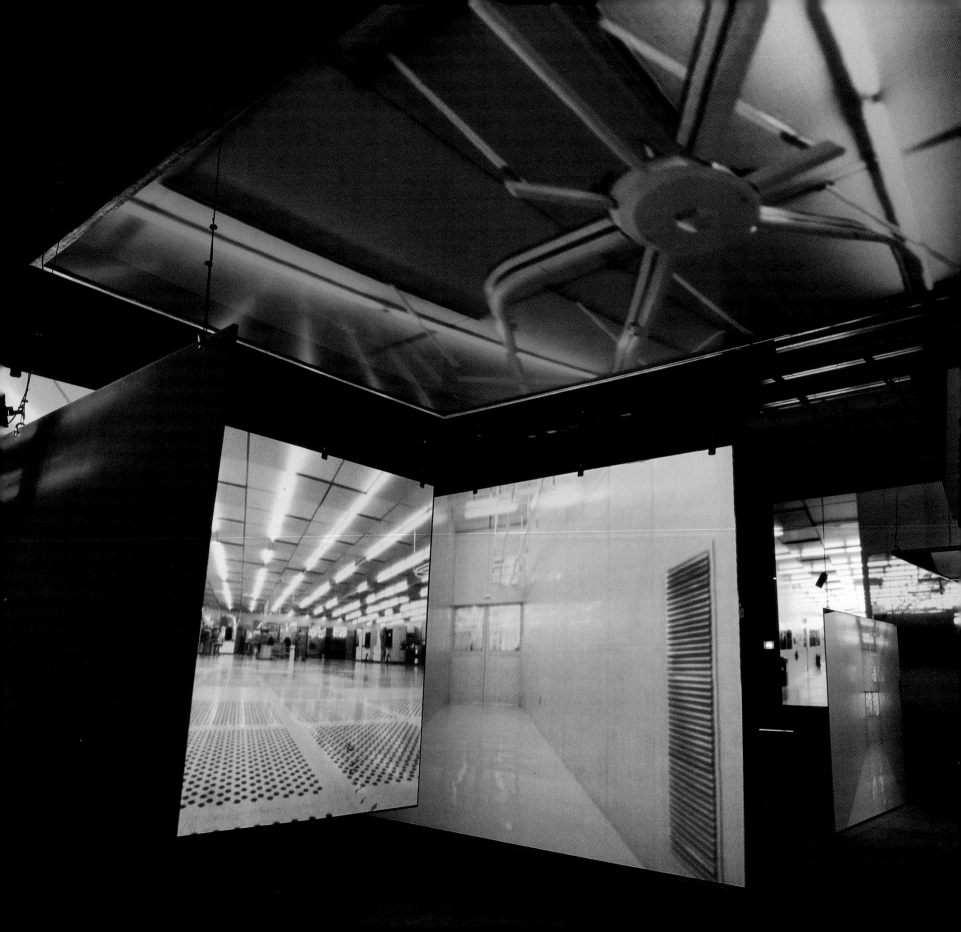

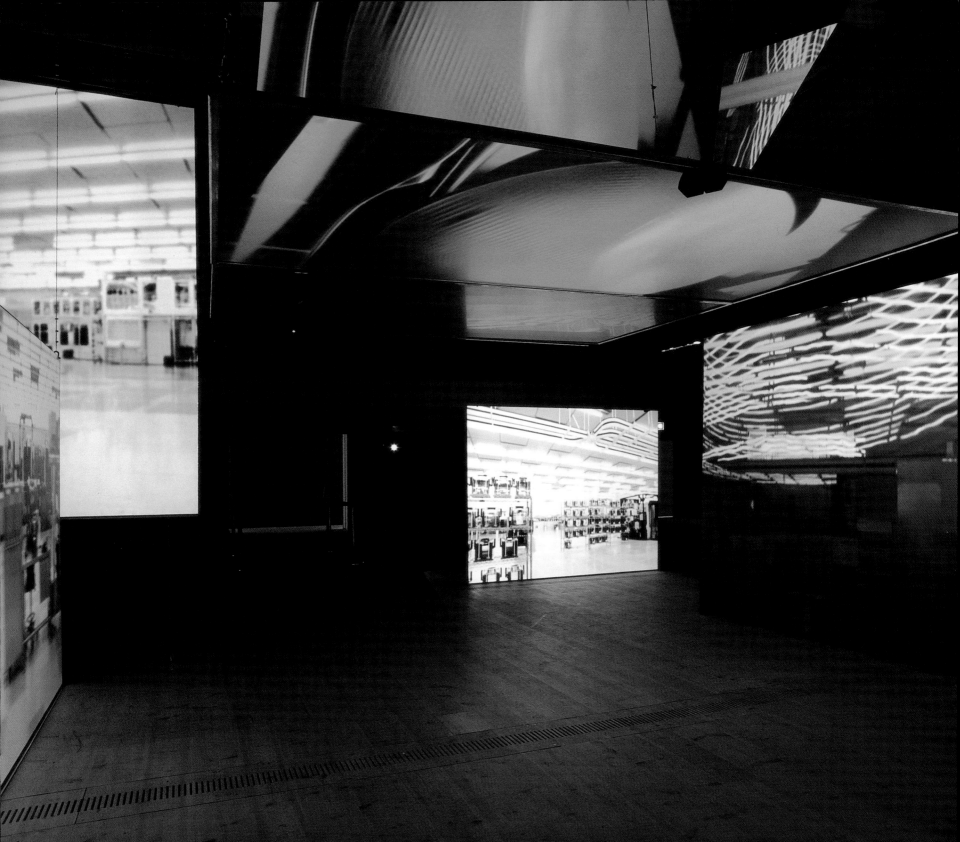

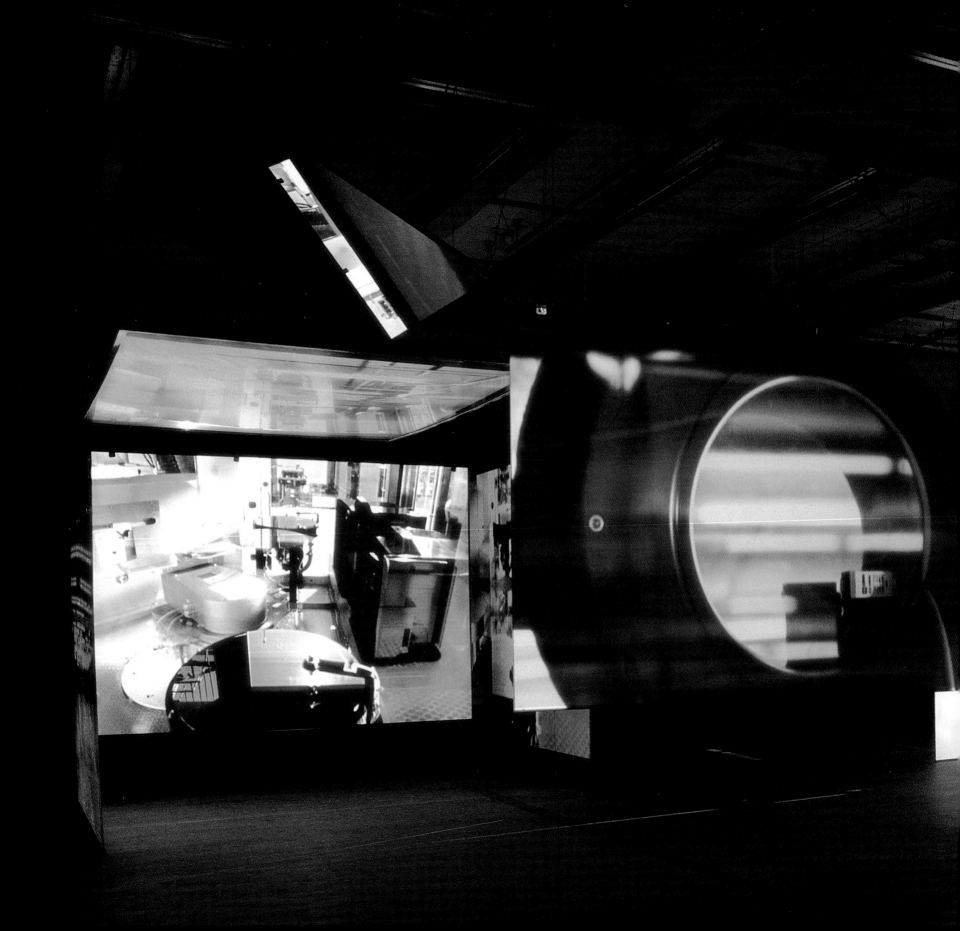

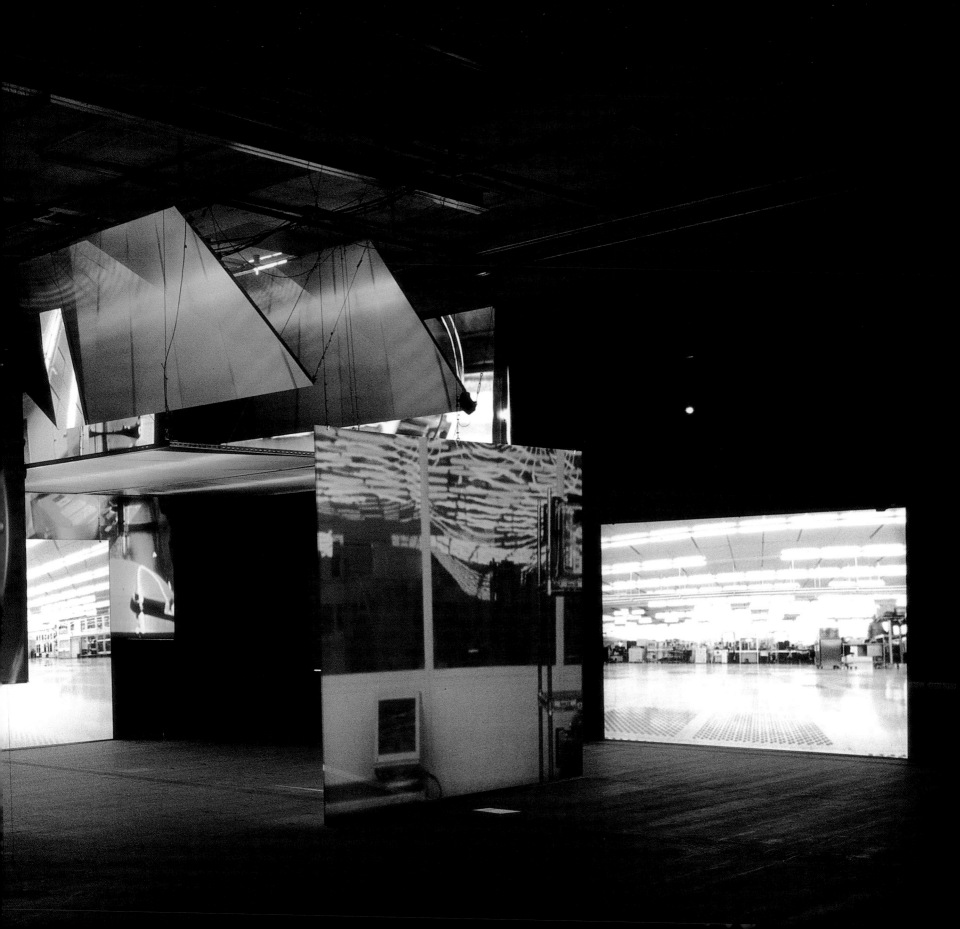

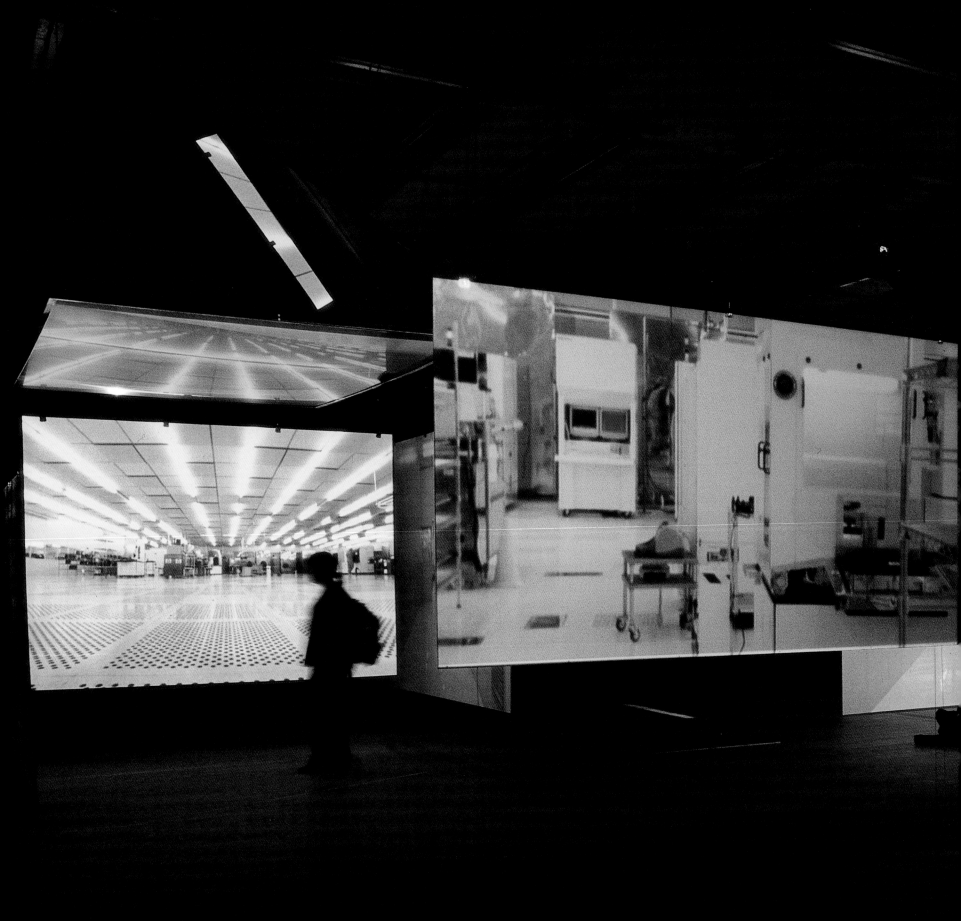

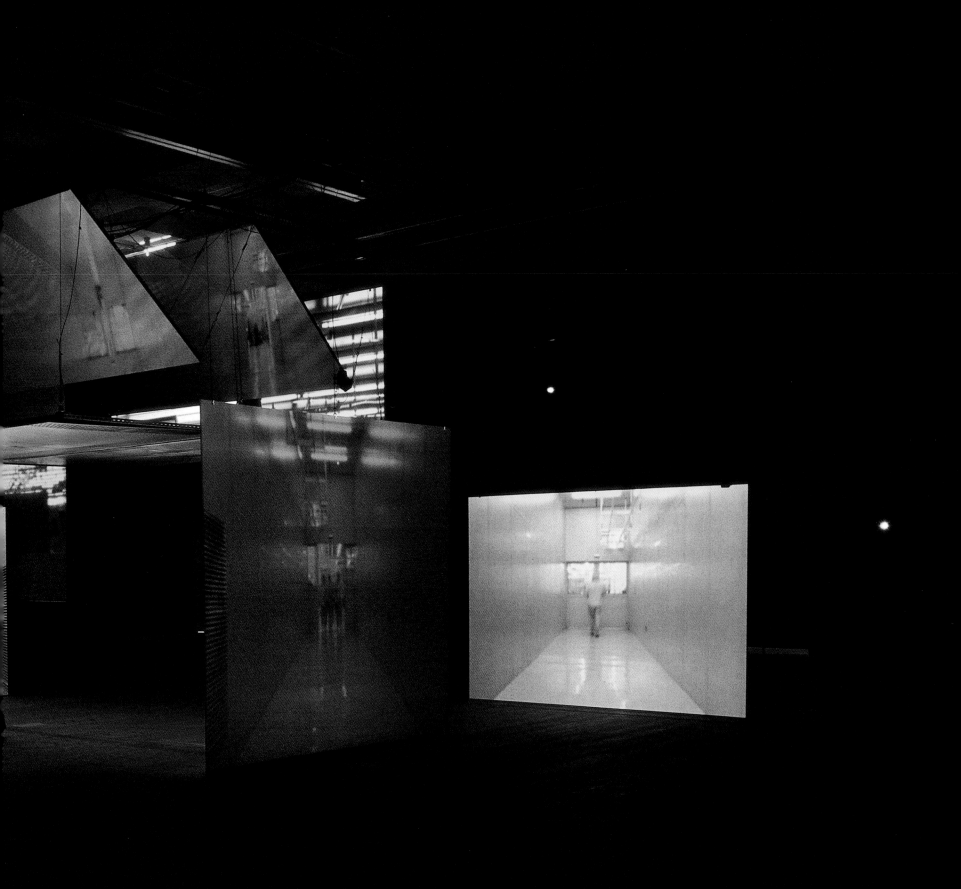

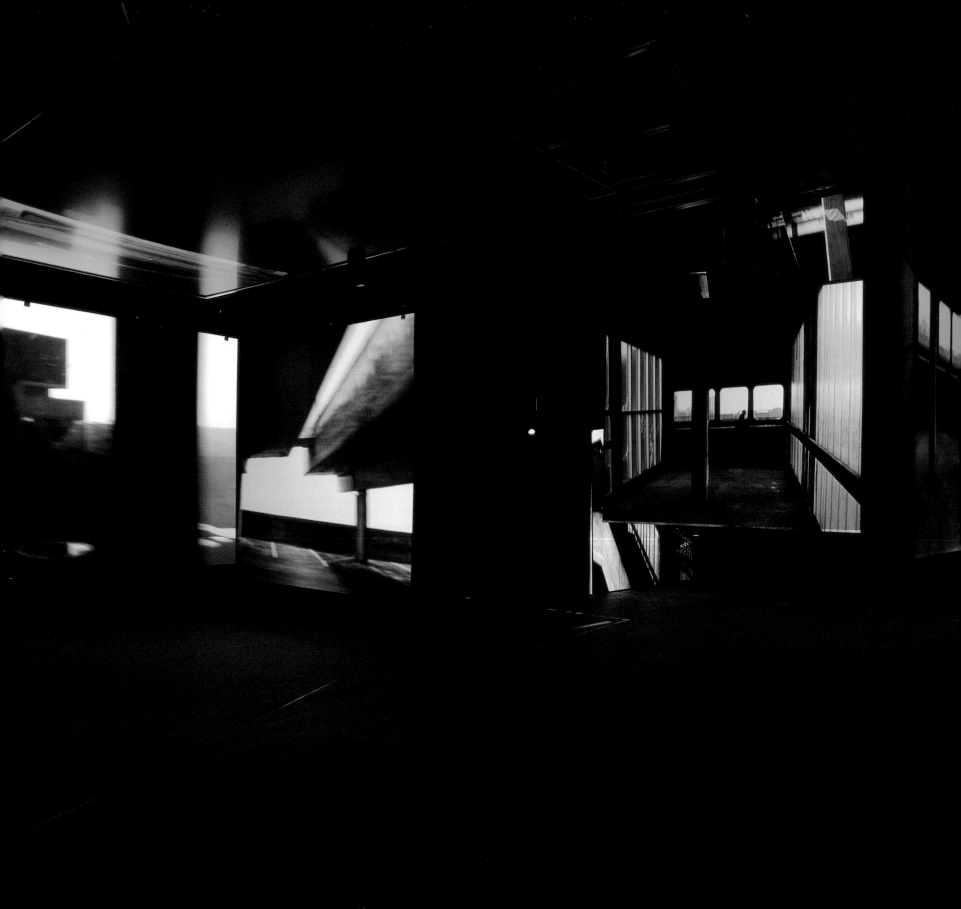

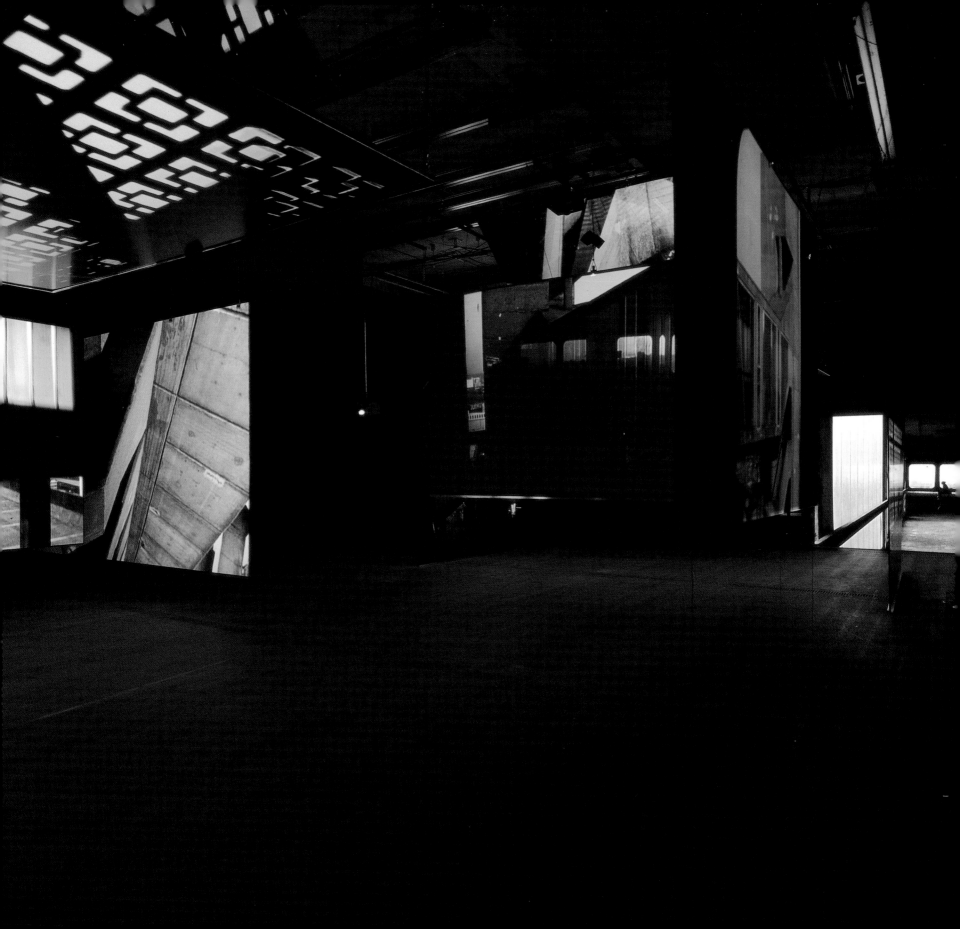

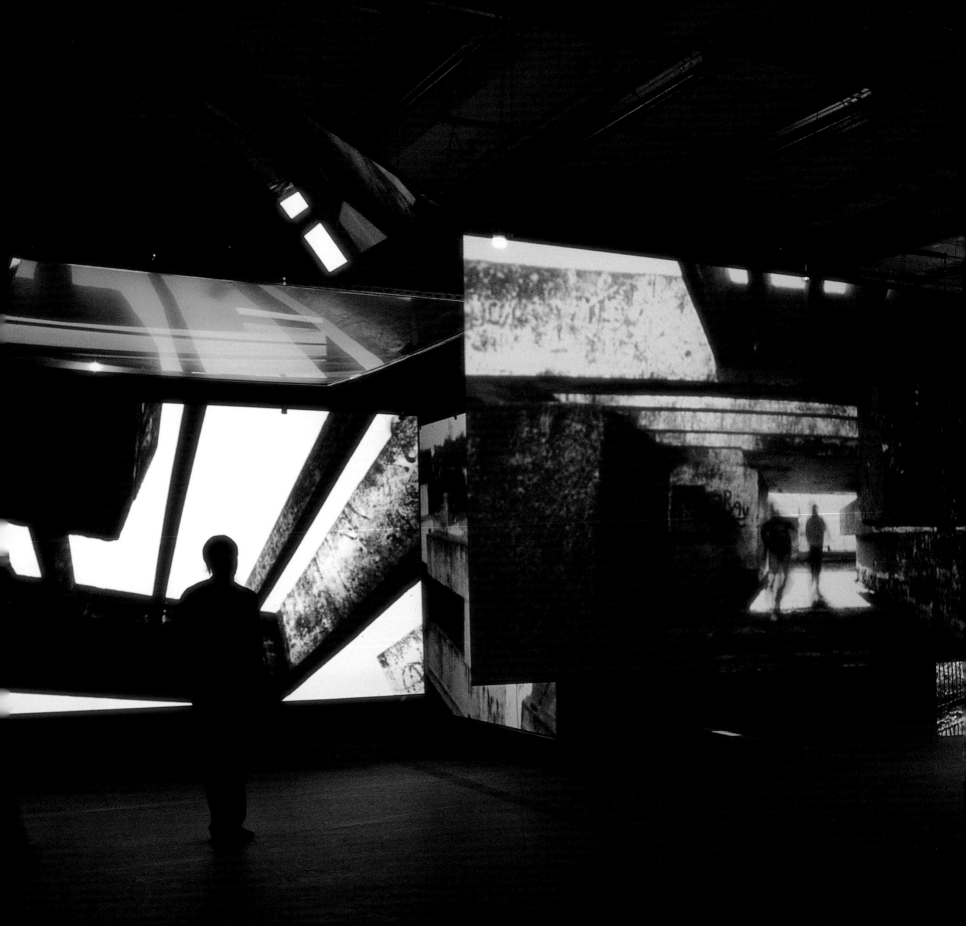

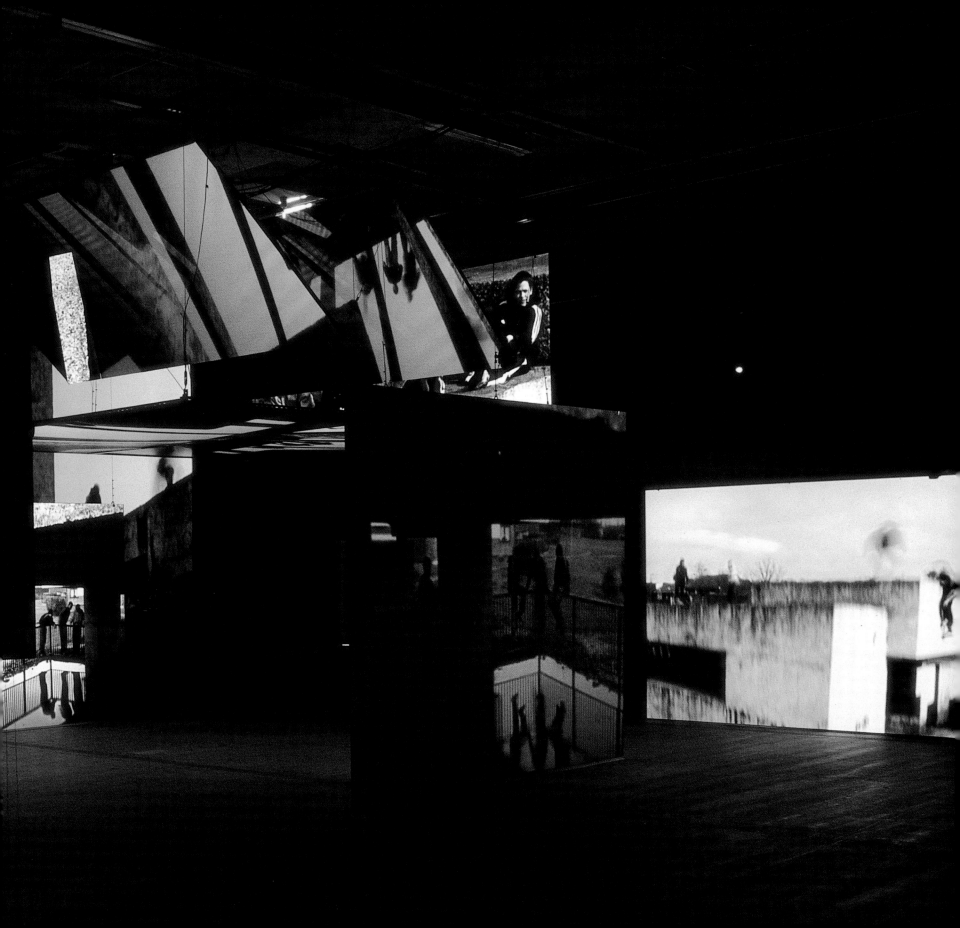

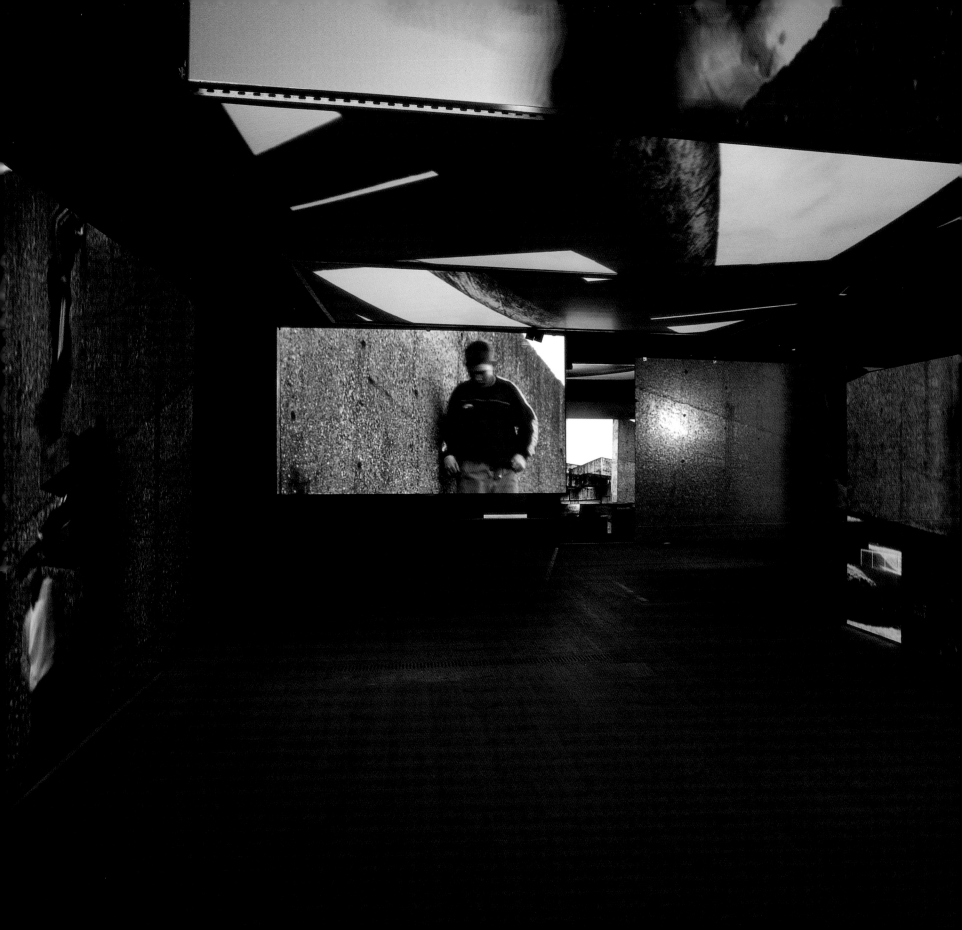

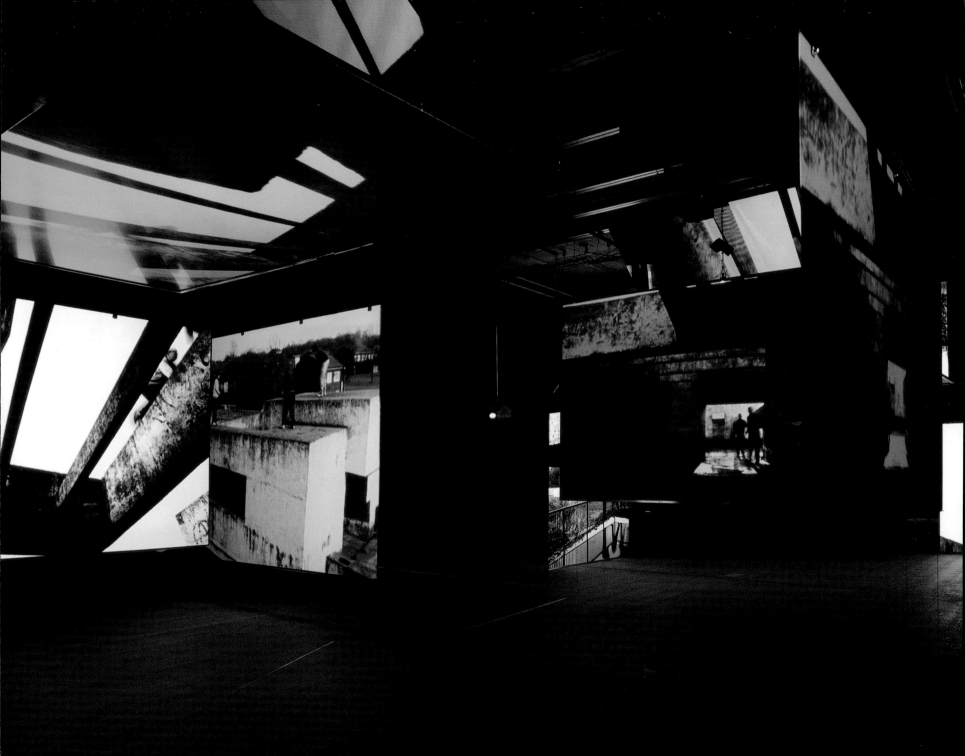

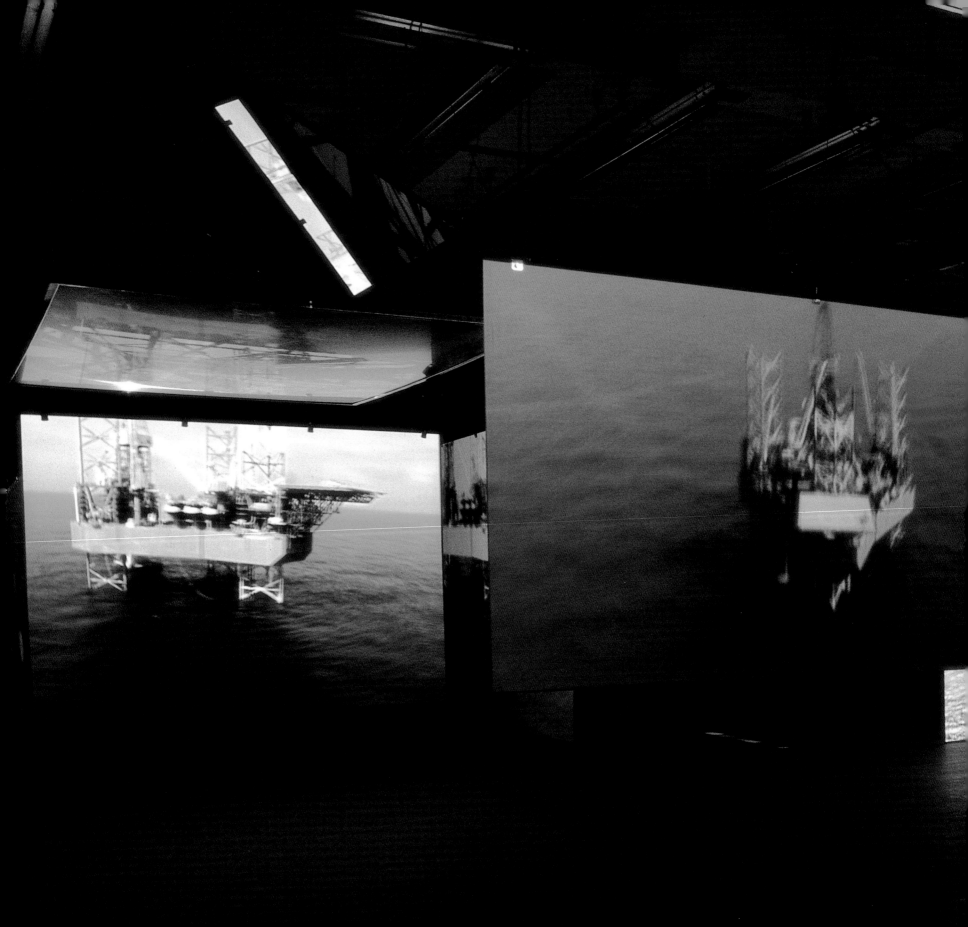

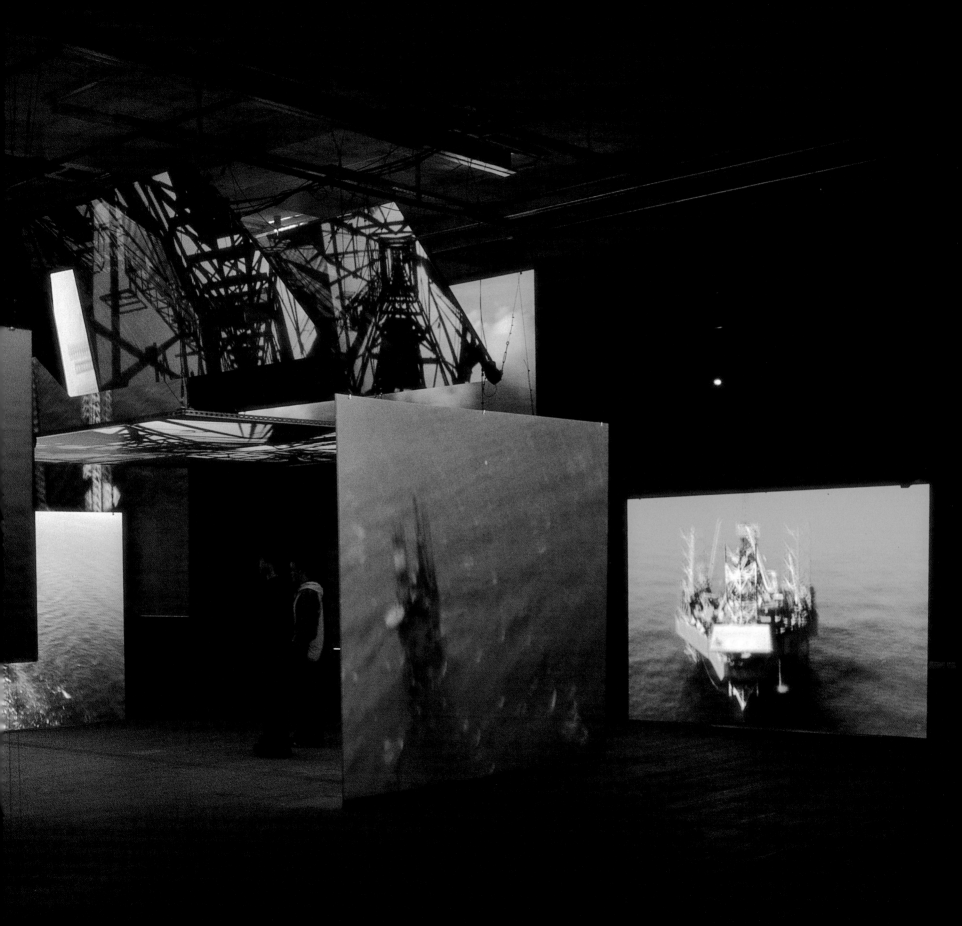

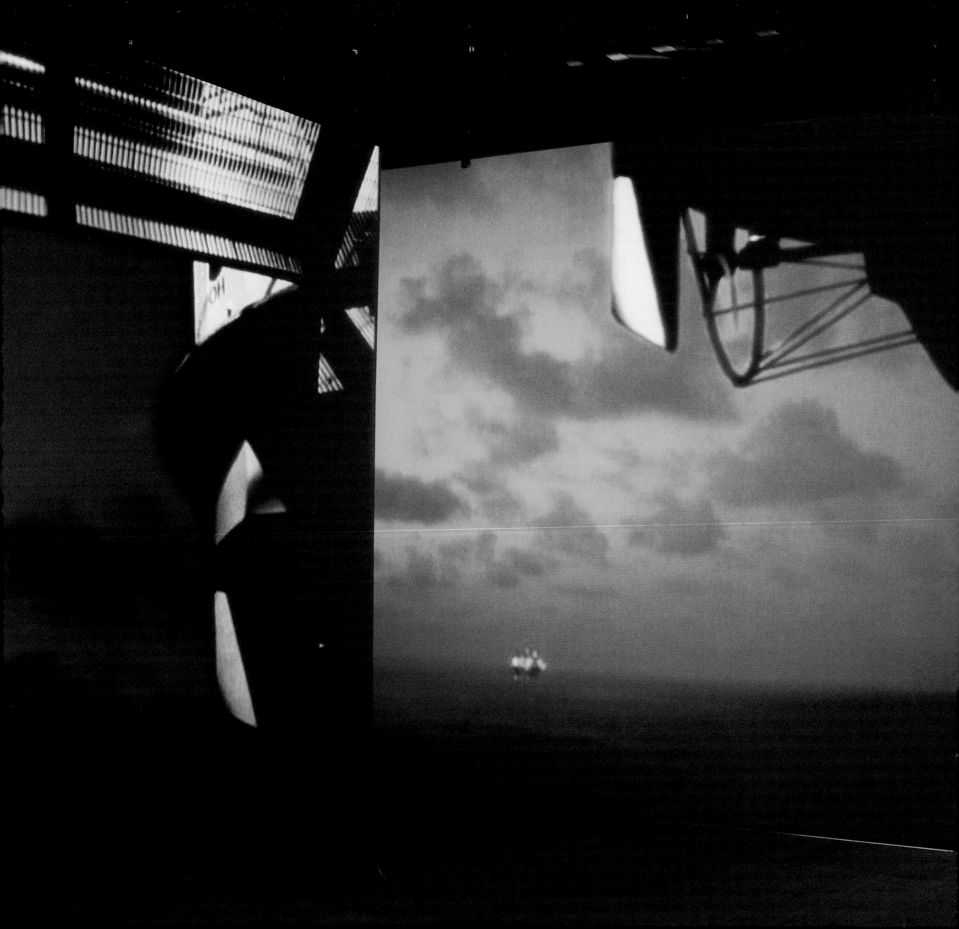

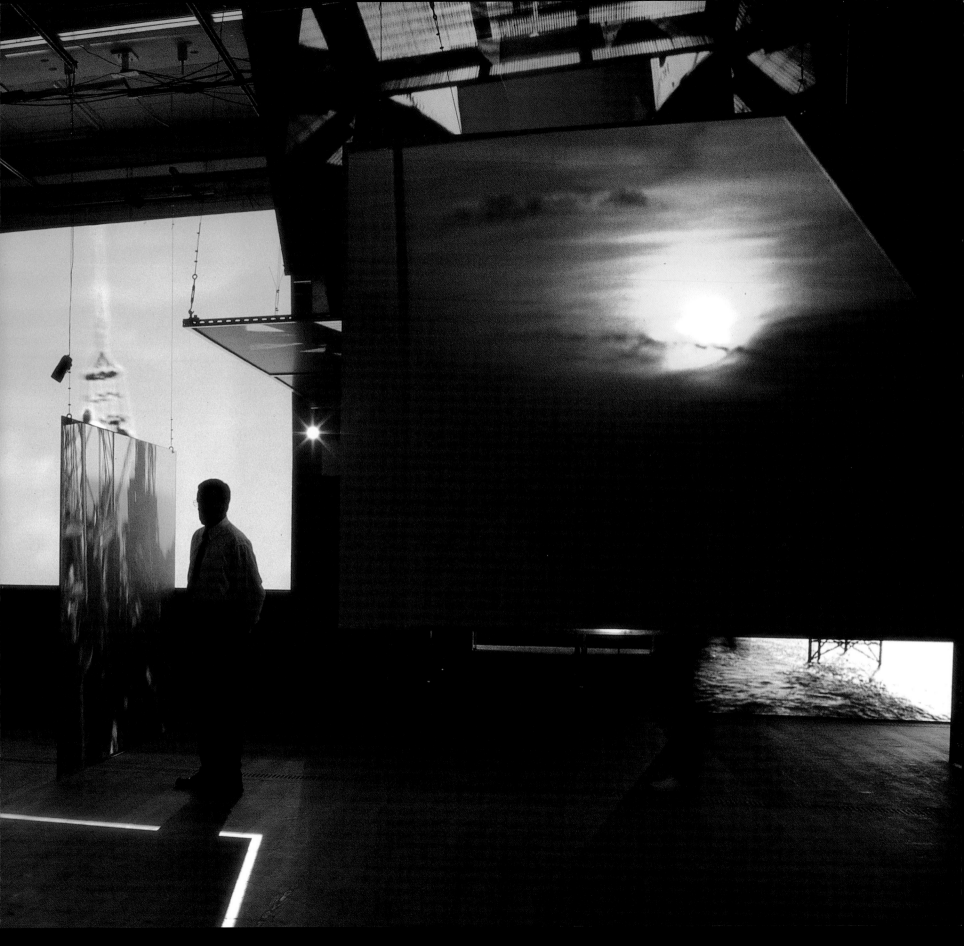

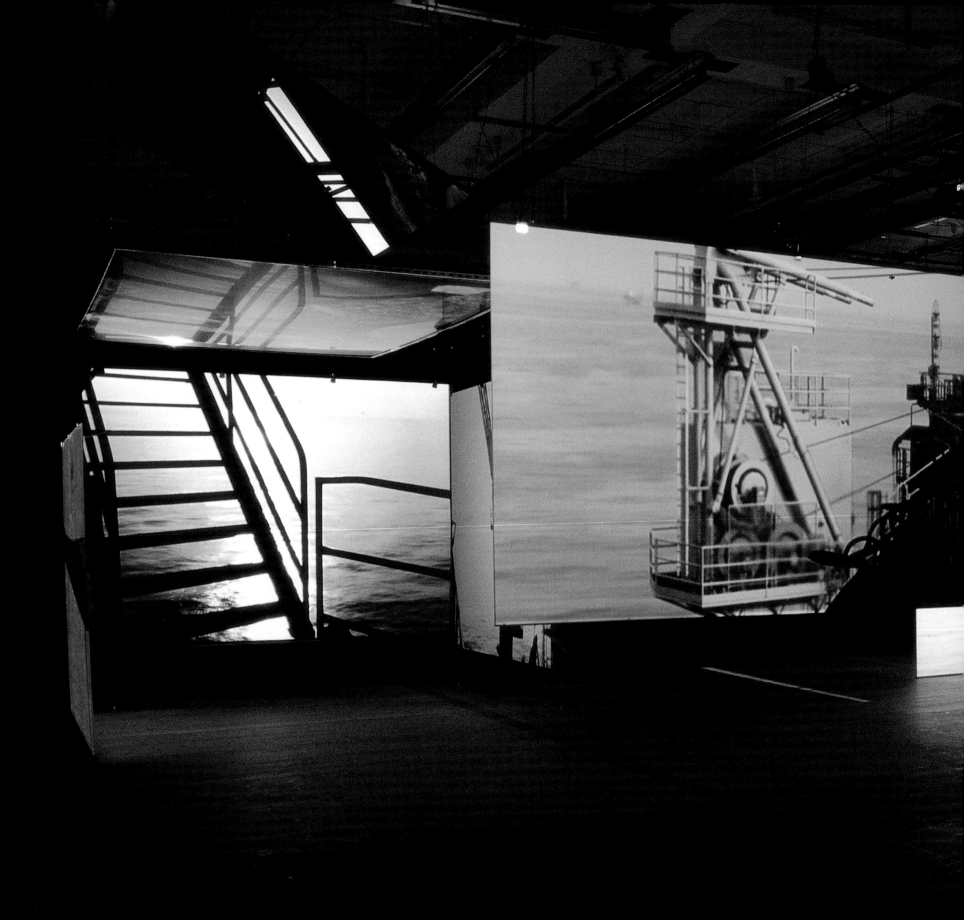

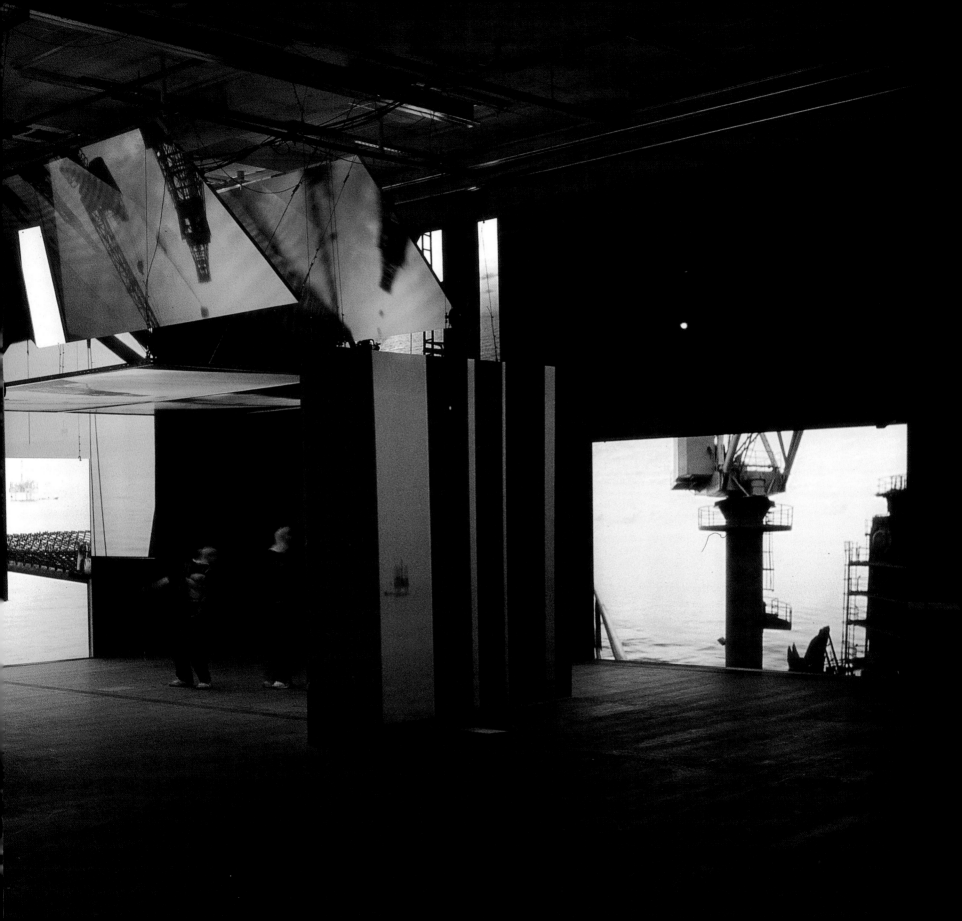

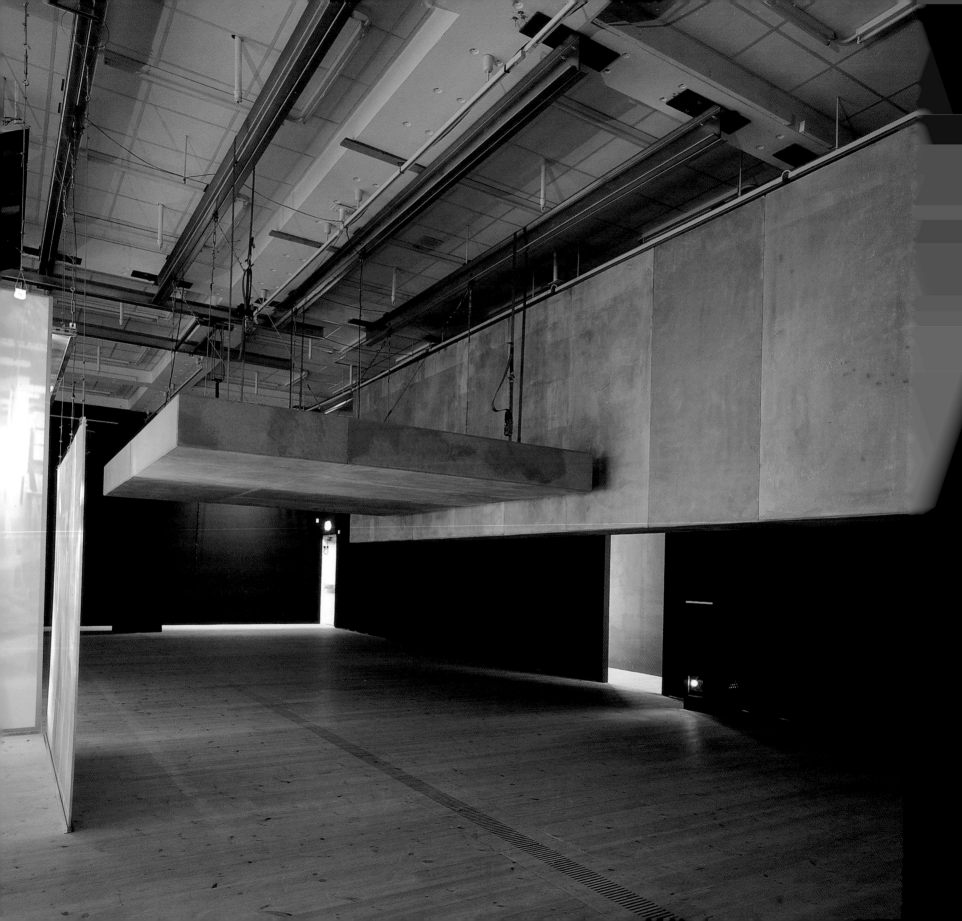

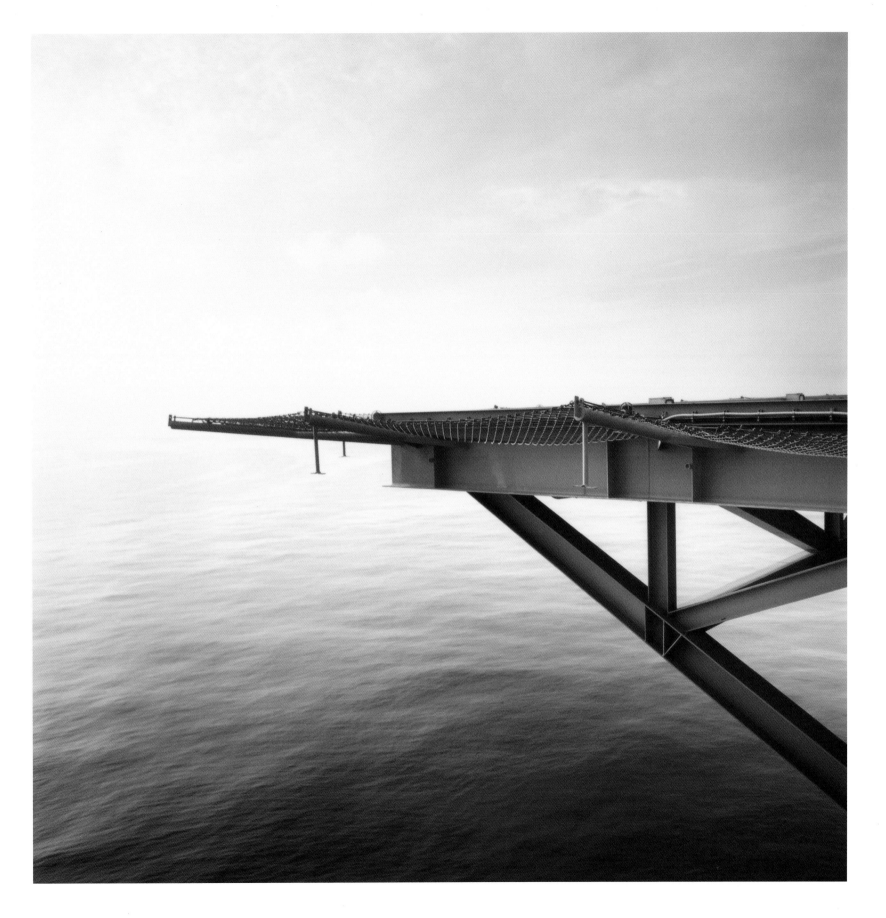

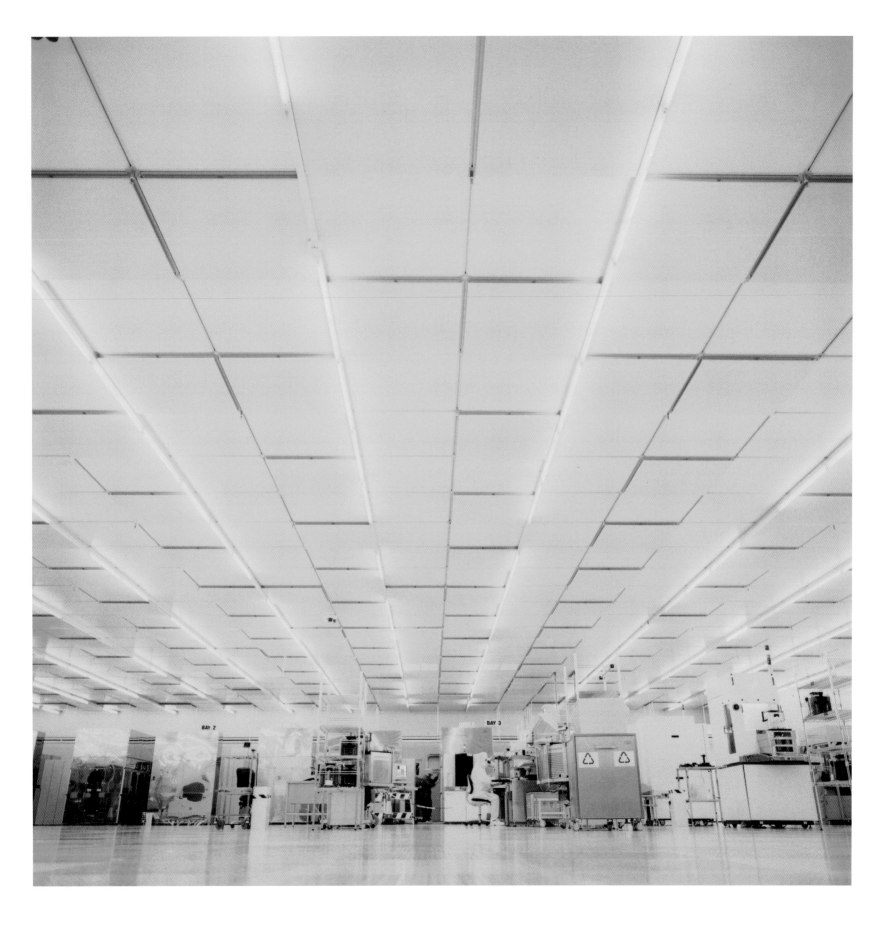

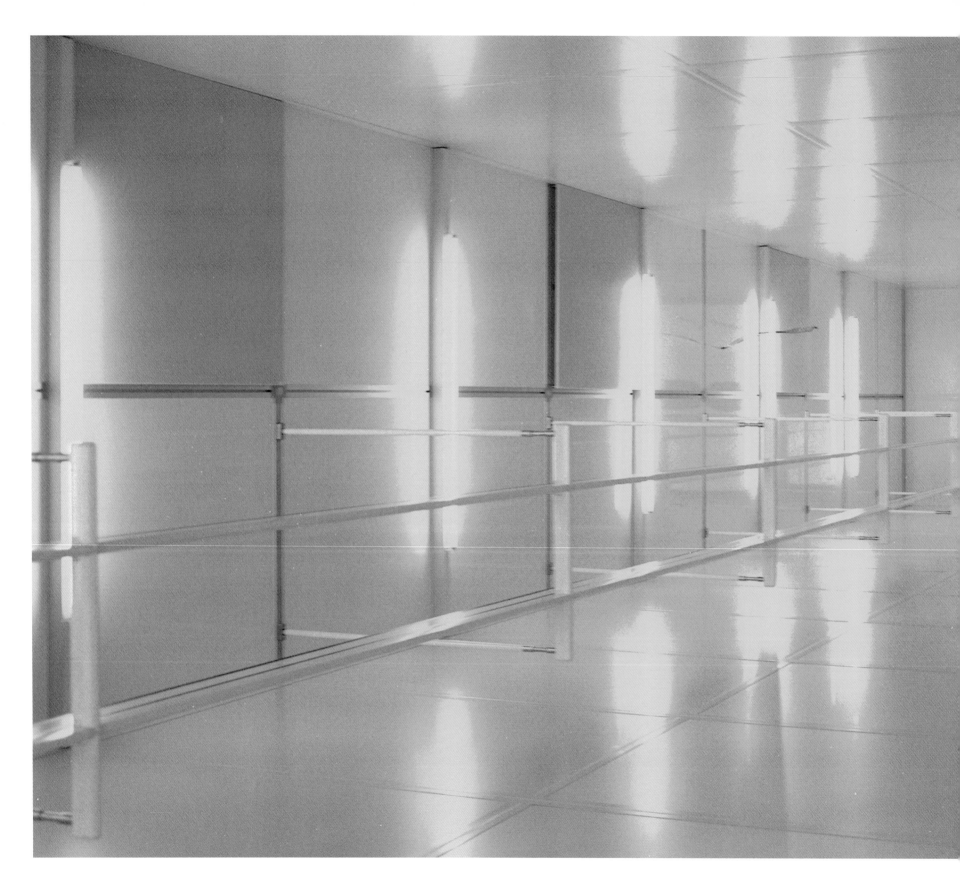

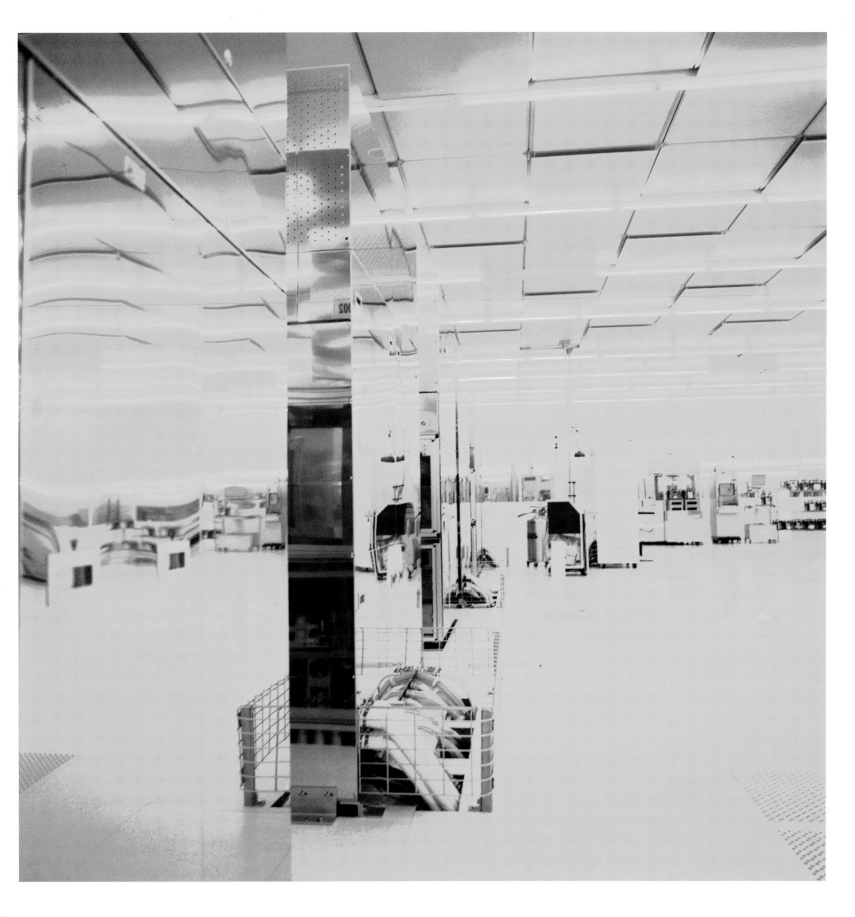

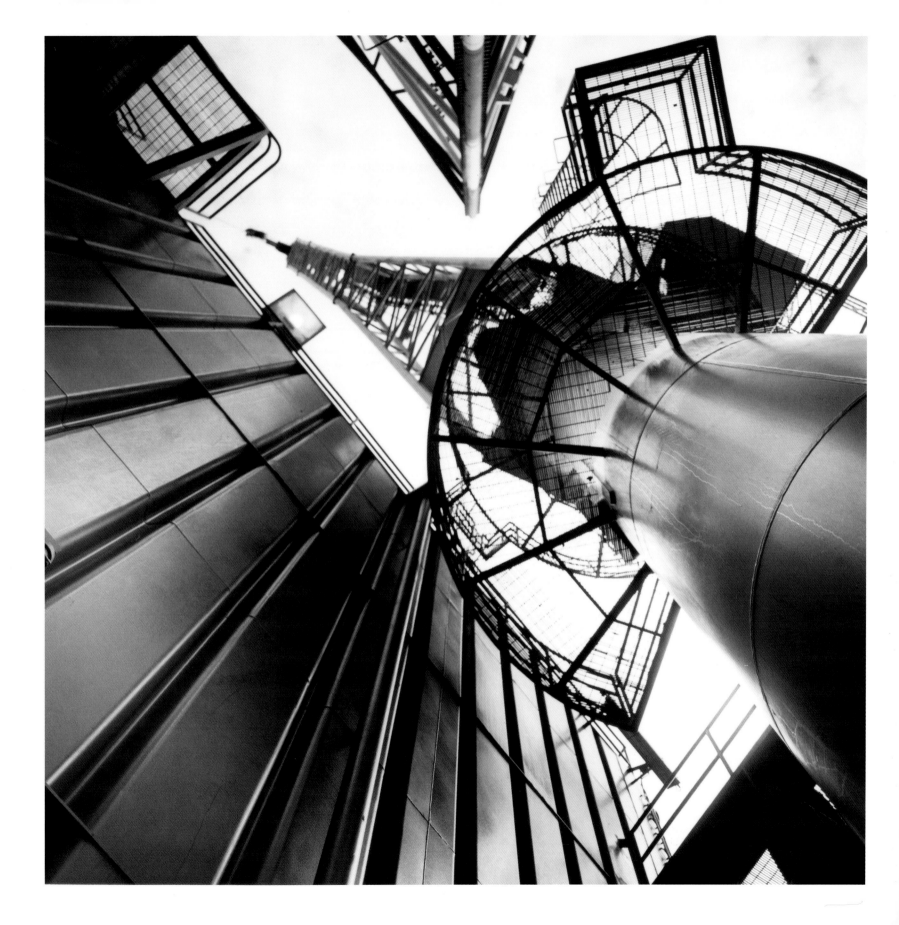

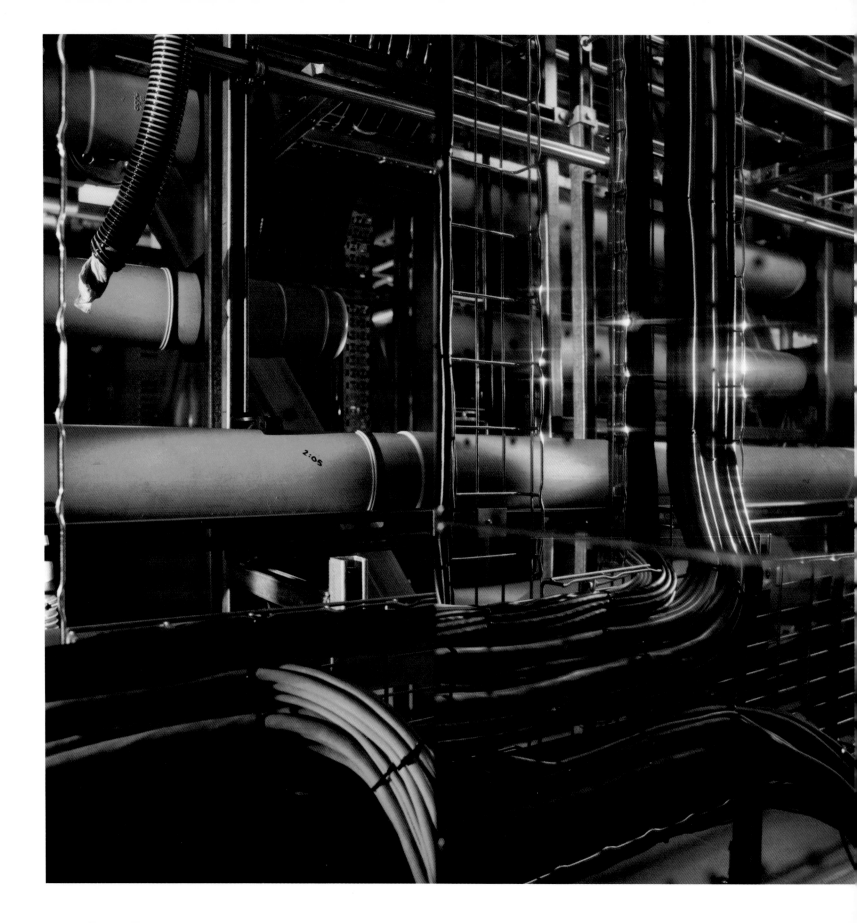

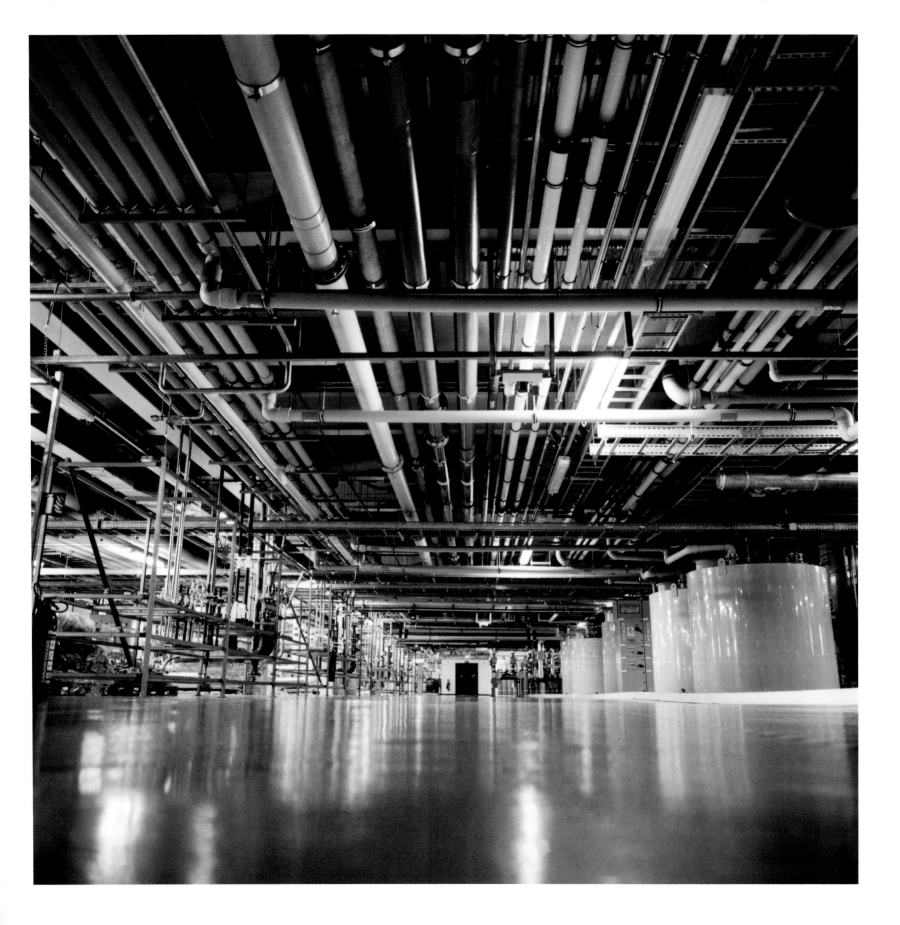

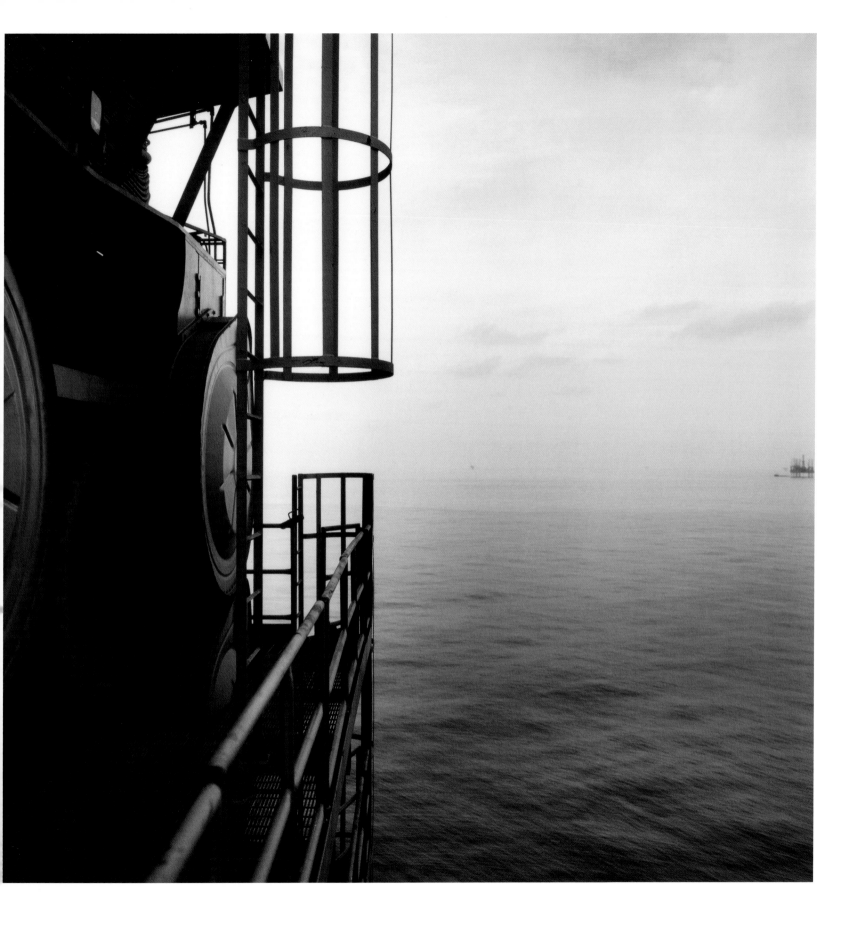

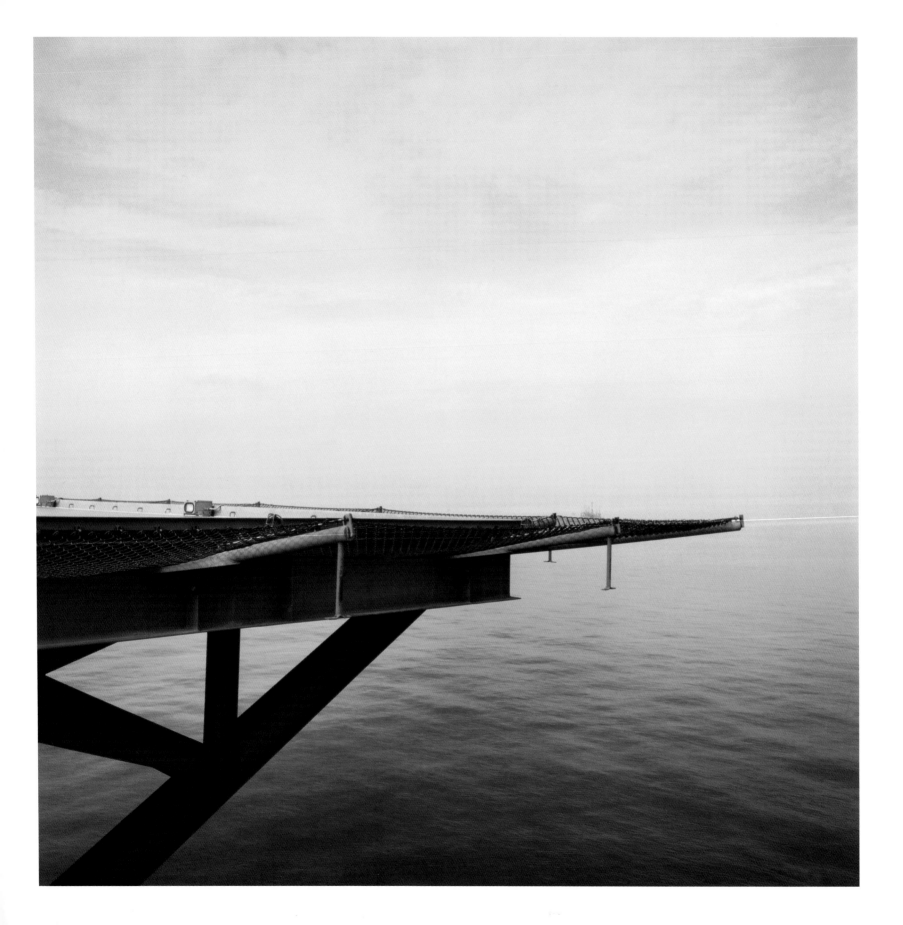

Mary Horlock: In your work you have always examined architecture, unpicking the messages and metaphors that it carries. But *A Free and Anonymous Monument*, although developing certain ideas from previous works, breaks with this significantly. For a start, having travelled all over the world, you chose sites very close to home. And instead of scrutinising a single place, you explore many: researching and filming in a number of locations, ranging from Modernist ruins to hyper-modern microchip factories. Was this always your ambition?

Jane Wilson: The project changed and developed over time, once we began filming. What we kept at the forefront was the idea of regeneration – there'd been this ambition to regenerate the North East in the 1960s, and it's still there. New towns and new industries, this was the backdrop to us growing up in Newcastle.

Louise Wilson: When we were commissioned to make a new work for the BALTIC, it seemed logical to revisit the local landscape, so to speak. But in a sense it didn't matter that we grew up there because all of the sites were unknown to us.

MH: The physical installation offered multiple perspectives as if to match the multiplicity of sites, but it was based on a real piece of architecture and your primary focus – Victor Pasmore's Apollo Pavilion. You used the Pavilion as a kind of 'set' on which to project the filmed footage, and this immediately added a new layer of representation, eliding actual and depicted space. How did this idea take shape?

LW: The starting point was always the Pavilion. Through suggesting its structure in the actual installation we were attempting to represent the space in both a physical and filmic sense.

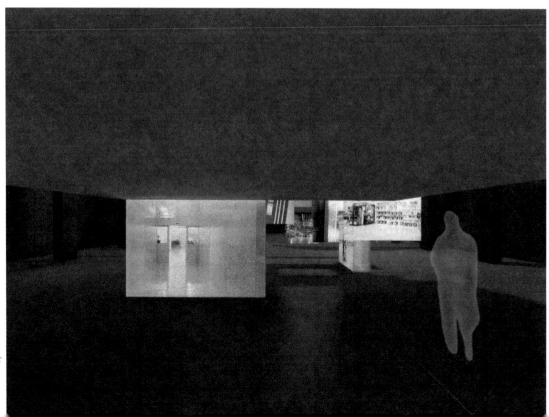

3D design for
walk-through

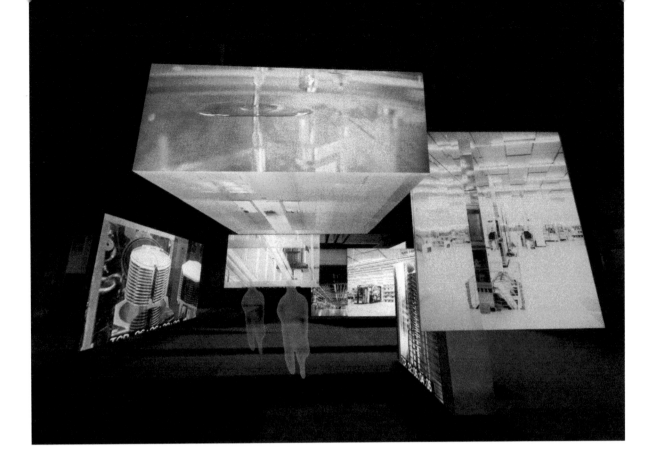

JW: The Pavilion is a unique hybrid of art and architecture. The fact that it was commissioned in 1956 and in the North East was pretty visionary for the time.

MH: Victor Pasmore may not necessarily be known to everyone, but as an artist he had a long and impressive career in Britain. His influence in the North East was partly through his teaching – at King's College in Newcastle – and it was here that he and Richard Hamilton set up their influential Basic Design Course in the 1950s.

JW: Pasmore was making abstract reliefs in the 1950s and walk-through environments in collaboration with Hamilton. The Pavilion has a lot in common with these works. At the time Hamilton was involved with the Independent Group (a loose alliance of artists, architects, photographers and historians), who were looking at science and technology and

the crossovers with art. There was one exhibition, 'Parallel of Life and Art', at the ICA in 1953, where various photographs were attached to the walls and suspended from the ceiling, making analogies to different structures in technology, science and the natural world.

MH: And some of Pasmore's ideas were literally inscribed onto the landscape, since he advised and helped to design Peterlee, the new town just outside of Gateshead where the Apollo Pavilion is found. Peterlee came about after the New Towns Act of 1946, an act that aimed to address the overspill from the great cities and create new communities outside them. Pasmore later said, "the idea was to build the greatest city on earth for miners."[1]

JW: But it never quite lived up to these high ideals. Berthold Lubetkin originally planned to build multi-storey blocks,

but there was a problem with subsidence. A new plan was drawn up by new architects and it was only then that Pasmore came on board. He was really excited by the idea, thinking about urban design as an extension of his formal experiments.

MH: But the screens of *A Free and Anonymous Monument* don't replicate the layout of Pavilion precisely, do they?

LW: No. We initially condensed the structure of the Pavilion to twenty six planes on two storeys. This still felt too complicated though, so we reduced the structure further to thirteen planes on one level. The design retains the look of the original with fake concrete walls at either end.

JW: There were only three ground-based screens, the rest were suspended. We wanted to keep the structure open. We always thought of it the way Pasmore did, as a place to view from inside and outside.

MH: Your previous installations have been more compacted: twinned corner projections flooding each wall from floor to ceiling, juxtaposing two distinct vantage points. Those installations were more immersive, surrounding us, drawing us into a centred viewing position. But *A Free and Anonymous Monument* pulled this apart, leading off in several directions at once.

JW: We were already familiar with the format of the four-screen installation. We wanted something different, something less fixed and deterministic. We were trying to create a walk-through environment where no position was privileged.

LW: You don't lose the narrative but it's not a sequential journey. As a viewer it was possible to move around, go behind or across screens, or stand outside of the installation altogether. And from this position you could see how other people were animating the space by their movement through it.

MH: Each of the screens shows different footage, a different aspect of the sites surveyed. Beginning with footage of the Pavilion, tracking shots follow its intersecting planes. The camera lingers on the spalled and scarred surface of the concrete with its painted out graffiti tags. Famously, in 1982, when Pasmore was shown what had happened to his Pavilion, he surprised everyone by posing for photographers in front of a graffiti-covered wall. It was reported how he said that "the children had done what I couldn't do: they had humanised the place and made it a social centre ... the adults ... didn't know what to do with the place. But the children had the imagination to make use of it." [2] He was actually referring to the graffiti on the Pavilion, but his words ring true for the way the children play on it.

JW: You do have to admire them – every time the Council found a way to block off access to the Pavilion the kids found a new way in. It's their territory. We were reverential of the Pavilion before we visited it. When we first went we did not expect to include people, and we were looking at it from a more formal perspective. But when we saw how the local children used it we knew we had to record it.

LW: The play of the children acts like a suggestion to the viewer. The edits shift simultaneously on each screen during all the footage in *A Free and Anonymous Monument* except for that of the children playing. This sequence cuts randomly in order to break up the rhythm, as well as situating the Pavilion each time.

MH: And this then shifts to images of a much more controlled and contained environment: an engine factory. We see the kind of automated industry that has replaced traditional activities like mining in the area.

LW: We filmed inside an engine factory in Darlington. We wanted to look at this idea of mass automation. The footage appears visceral because of the scale of the projections. There's one moment where white-shrouded spray guns surround you, their movements mirroring human movement. It fills a whole section – it's almost like a corridor of Duchampian brides.

JW: These scenes are perhaps typical of mechanised industry – vast assembly lines are what you'd expect to see…

MH: Whereas the images that follow on from this sequence are harder to read. We see inside another factory – a recently refitted microchip manufacturing plant. It's so hi-tech you'd barely know what goes on there.

LW: The factory was originally owned by Siemens, and it was a very important manufacturing plant in the North East, but it had to close when the market crashed in the early 1990s. Then Atmel – an American company – took over and it diversified. Atmel is about mass automation and as a purpose-built architectural space it is a phenomenon in its own terms.

JW: It was strange to see the human presence so far removed from the manufacturing and production. They seem to have done away with the human to achieve perfection… Atmel is a very hi-tech environment but technology will always be

advancing, we work with technology and film so this idea and interest interlinks… you follow the developments that are being made. Atmel represents this and it is ironic that it was right on our doorstep, near where we grew up.

MH: But we could be anywhere in the world. Atmel is a very abstract, airless space.

JW: But these are not signature shots of it – that would be too close to straight documentary. We look a lot at peripheral spaces. To understand the essence of a building's own phenomenon you often have to look at the inconsequential, the peripheral.

LW: And it's also about how we situate the body within the frame of each shot. For example, with the photographs, we'll play around with crops and we might shift the perspective, and this might make a simple view down a corridor more disorientating. We are re-framing how you position yourself. Nothing is digitally manipulated but we might rotate and

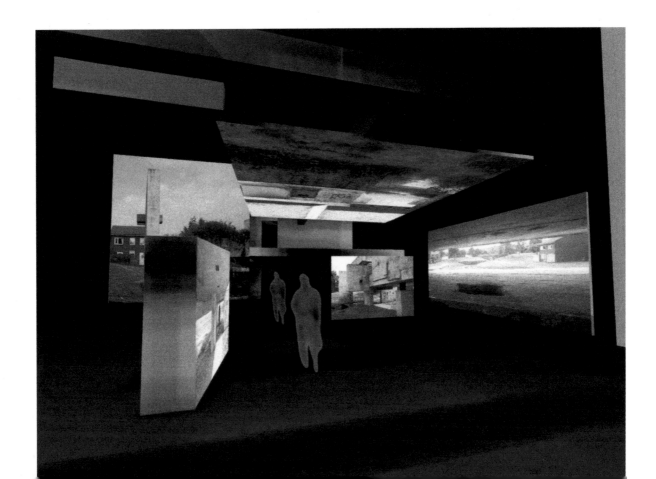

flip an image to one side and make it more artificial, and this is something we carry through into the film-making.

MH: And you exploit reflective surfaces so there's often a warping of space, a play of images. In the photograph *Safe Light: Divided Ballroom* (2003) what appear to be split screens are mirror images of the same chamber of machinery. You disorientate the viewer all the time.

LW: I think there is a slippage and we get very excited about that. Your natural impulse is to situate yourself in the image and we make it more difficult, especially as the images are big and hung low to the ground. You feel you should have a clear physical relationship to them but you can't.

MH: How do you build a relationship with the spaces you film in?

LW: We go back, engage, see how things change… there is

a kind of emotional investment. Also, I know this sounds strange, and I don't want to overstate it, but you could say it is a bit like 'method acting'. I think we do adopt roles.

MH: Do you think this approach might be informed by your gender?

JW: Well, we certainly do not set out to colonise the space, and we aren't going for the 'main event'. We identify specific moments or incidents, but consciously avoid the obvious, looking more at in-between spaces. I always get really interested and excited at those moments when I am in the space and the reason why I am there is suddenly unimportant, or rather it has been eclipsed or overtaken by something else.

LW: It is that moment of collapse.

JW: And it can be a moment of clarity.

82

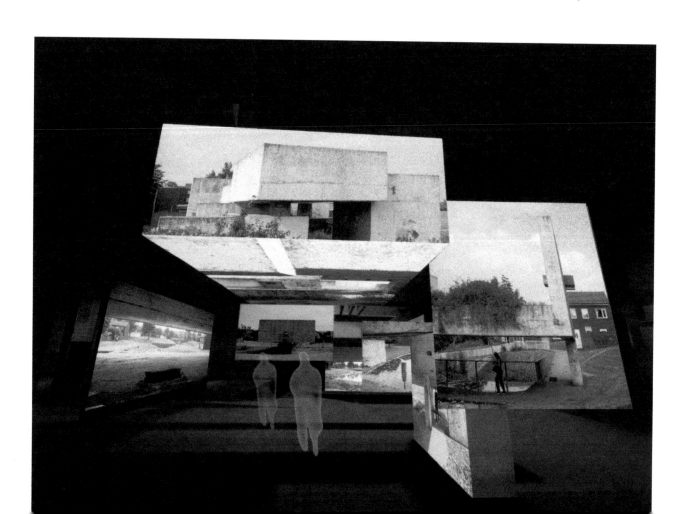

MH: After Atmel the setting changes again, and we go from this pristine, enclosed environment back to degraded, concrete surfaces and the open air. On one screen a mysterious silhouette is glimpsed descending a staircase, whilst elsewhere we look out over a misty cityscape. This is the view from the multi-storey car park of Gateshead shopping centre, a powerful Modernist block built at the same time as Pasmore's Pavilion. We jump from the future (or one version of it) back into the past, although neither is particularly welcoming.

JW: Pasmore's Pavilion is much less well known in fact, whereas the car park is right in the centre of Gateshead. There's a solemnity about it, it's an imposing presence, but it's just as much a monument to an idea really, since it was supposed to revive the economy and the community but failed to deliver. The rooftop restaurant never opened because of fire regulations and now the car park has been declared structurally unsound and closed to the public.

LW: So it's almost the perfect symbol of 1960s regeneration. You could say it's a big folly, which is what some people might call – what some people have called – the Pavilion.

MH: Like Pasmore's Pavilion the car park has a history of abandonment, exclusion and deterioration. The Pavilion has been listed and could be saved for now, but the concrete of the car park is rotting and will have to be demolished. Gazing across its derelict structure and thinking back to the preceding scenes it's hard not to wonder what will happen next. Reinforced concrete is now so redolent of failure: architectural Modernism's failure to build a better world, the failure of new towns to revive local economies. We locate our quest for progress in the material world but the material inevitably breaks down, again and again.

For a long time artists have distanced themselves from Modernism – its utopianism, its drive for the new, its model of historical progress – and the only way to engage with it was through a broad critique. But there's been a lot more interest in it recently, and a different kind of engagement. Would you agree?

JW: There are many artists of our generation who examine Modernism and its legacy. We feel a responsibility to be articulate about it since it's in the collective memory, but at the same time we don't feel involved with it. Every country has had its successes and failures, so it has become a kind of universal language and with that it might appear pretty generic. But for us there was a real specificity to the Apollo Pavilion.

MH: As women artists you probe what you yourselves would admit are masculine territories, bastions of male power where women have been generally marginalised or excluded. Certainly *A Free and Anonymous Monument* accesses and exposes a whole series of macho spaces, and the history of Modernism is dominated by this 'men's club' idea especially. Do you want to challenge it, or skew it somehow?

LW: We are interested in this notion of exclusion, and with it the sense of exclusivity. I'd say that as *artists*, we are naturally curious to gain access to seemingly exclusive territories, and Modernism was one of those territories.

JW: You could ask: how would you feminise Modernism? We wouldn't try…

MH: The oil rig was a pretty extreme conclusion to the footage, and one of the most macho places imaginable.

LW: It's also a very Modernist structure: with an oil rig function dictates form, there's no architectural surplus. And this offers an interesting contrast to the Apollo Pavilion where it was more a case of form dictates function. But then, an oil rig can also be described as an isolated platform in nature, much like how Pasmore viewed the Pavilion.

JW: You could also say that a rig is the closest thing to a space station on earth, a self-contained and isolated structure cut off from the world for months on end. The men who work there have to deal with this oppressive, uncomfortable, closely regulated environment.

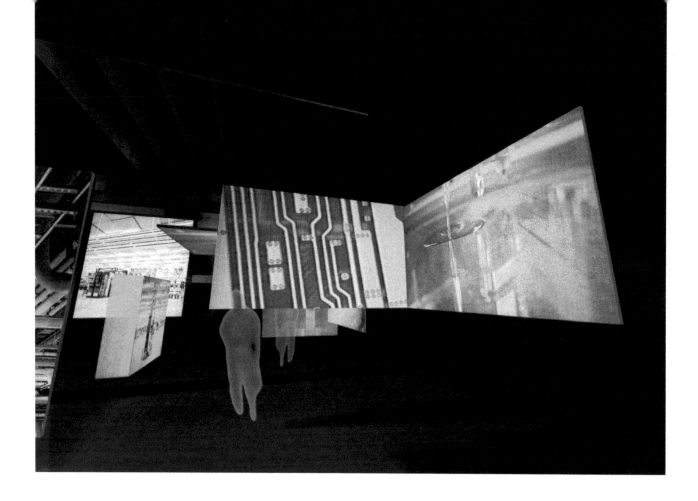

MH: The camera hovers over the oil rig, circling it, and then suddenly we are on board, watching the drill spew out mud on one screen or scanning an ordered and empty interior on another. Everywhere we look there is a different view: a close-up, a long shot, the open sea or a tidy locker room. Once more we are in every space simultaneously, once more there is little sign of human action. All power is given over to machinery.

JW: It's quite chilling; rigs are also dangerous places. We both have memories of the Piper Alpha disaster in the early 1980s. Our father (a naval architect) was involved in the design of a lifeboat specifically for the rigs, it was special in that it was fire retardant and would always right itself in the water.

MH: In *A Free and Anonymous Monument* individual and shared experience overlap: your personal memories and ideas interweave with a broader historical narrative. But I think of this in terms of the actual, physical experience as well; inhabiting the installation we are very conscious of our bodies and how we move, and when other people enter things change: we watch them, follow their shadows, listen to them. The structure of the work becomes both a form of envelopment and a form of exposure, a hiding-place and a meeting-place.

JW: We were trying to picture architecture but capture something of the physical reality of it as well. The work depicts space but also disrupts it, and so your sensations are both confused and heightened. And people are the chance factor, breaking into vistas and viewing points, moving freely… they complete the work.

MH: One critic recalled his amazement at the complexity of it – the multiple projections, the wires and lights – commenting on what "looked like an overcomplicated stage set"[3] but he took this as part of the experience. It was a further dimension to an artwork already rich in behind-the-scenes glimpses of working environments. Things were not hidden away; the wires and mirrors were evident; the technology was there to see.

JW: This was something we wanted – the technology is part of our material, and so showing it was logical. A lot of artists now are thinking about the 'surround experience'; they want to reveal the mechanisms behind the work as well as showing the work. There's a transparency – it's not supposed to be some magic trick or illusion. We wanted to be more inclusive.

LW: All forms of art are moving towards installation. There is a general desire to intensify any encounter with an artwork, but at the same time I think it is important to retain a sense of integrity within the work.

MH: In *A Free and Anonymous Monument* the contemporary environment confronts its historical predecessors. You ask a lot of questions about just what is progress. I wondered what thoughts you've had since completing the work, about how it's seen now and how it might be seen in years to come.

JW: It makes me think of failure, of a kind of entropy that occurs in the quest for advancement.

LW: In some respects, for artists, a work becomes almost obsolete upon completion. But, with *A Free and Anonymous Monument*, I've seen it maybe twenty times and because of its complexity I still don't feel that that's enough.

1 Peter Fuller with Victor Pasmore, 'The Case for Modern Art', *Modern Painters*, p. 30
2 ibid.
3 Adrian Searle, 'You are here', *The Guardian*, 16 September 2003

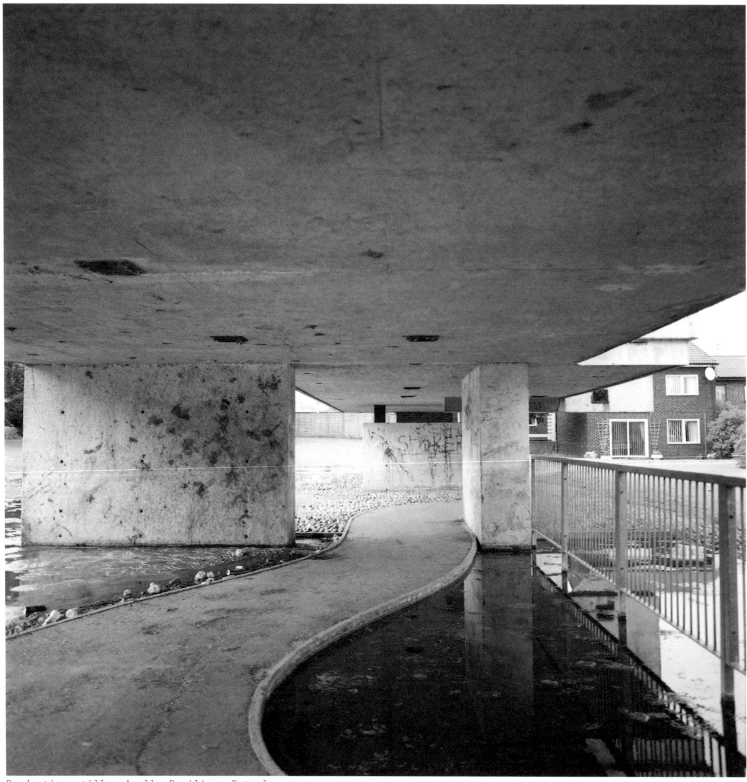

86

Production stills: Apollo Pavilion, Peterlee

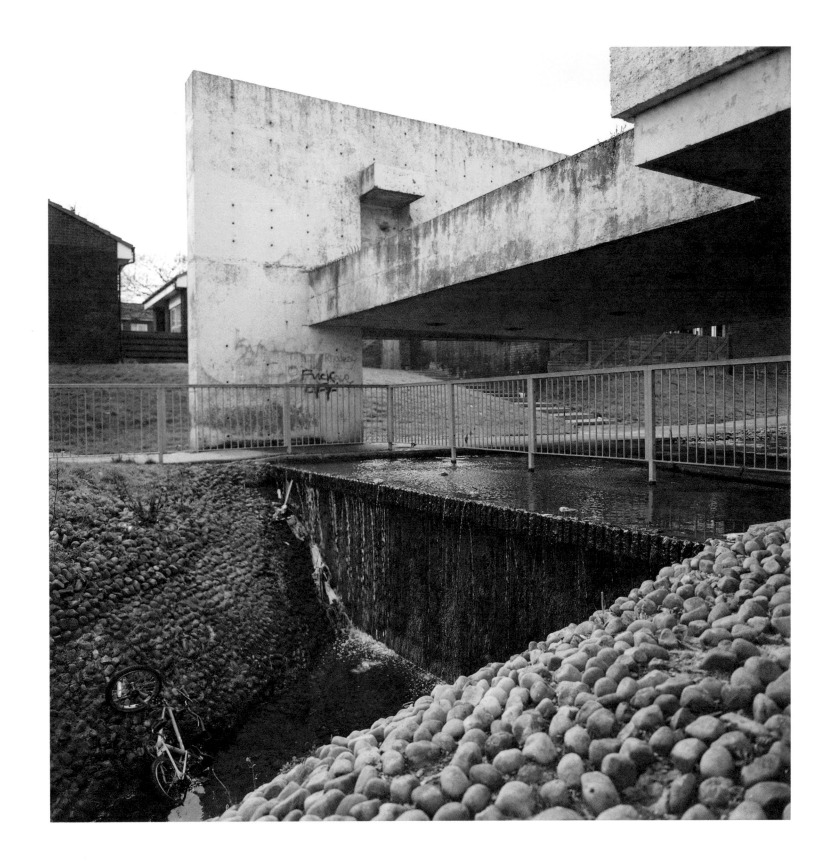

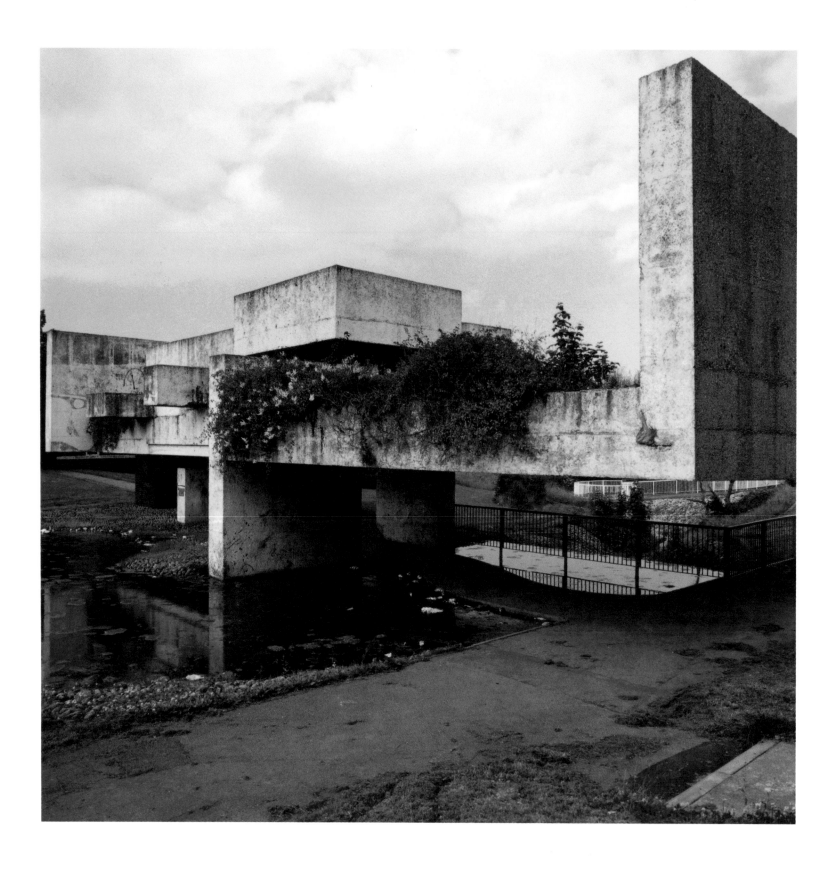

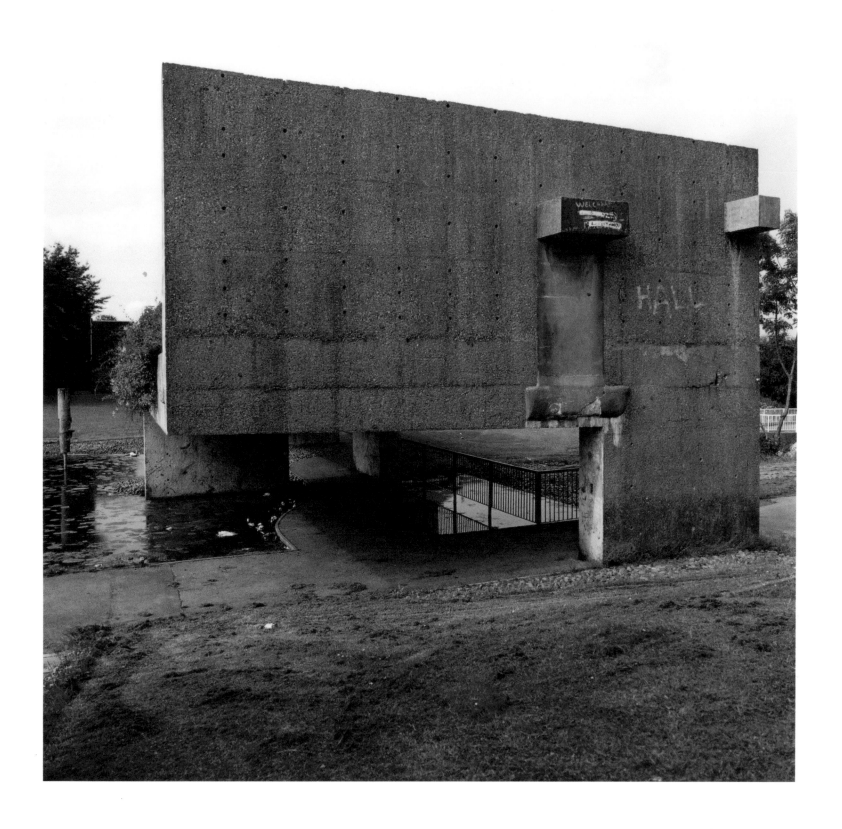

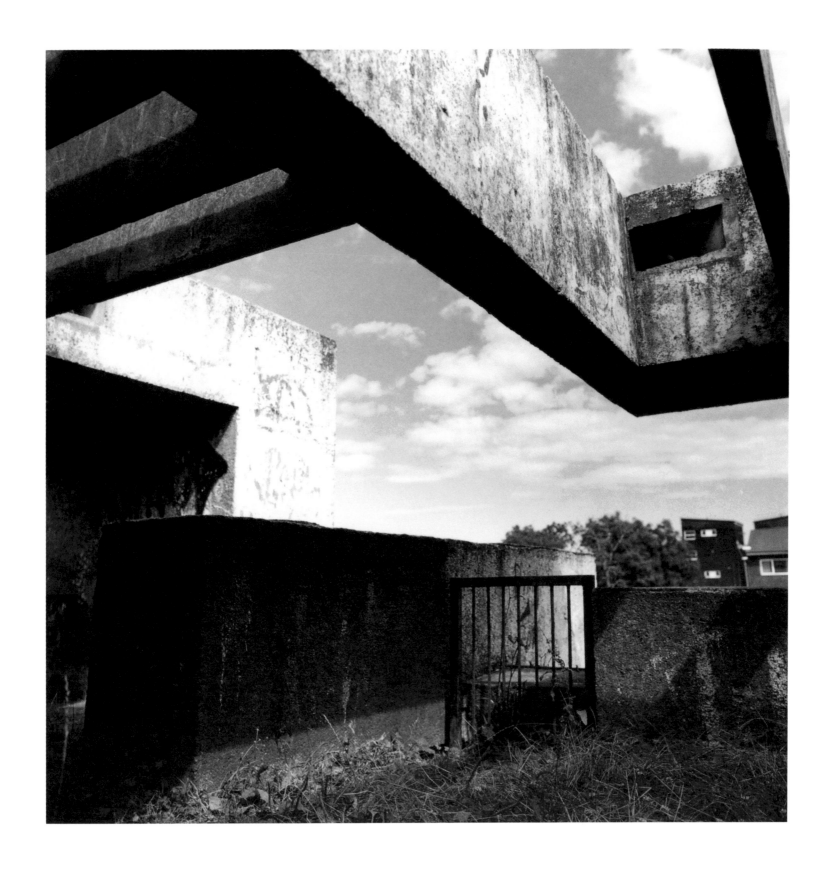

Jane and Louise Wilson

1986-89
Duncan of Jordanstone College of Art, Dundee,
BA Fine Art (Louise)
Newcastle Polytechnic, BA Fine Art (Jane)

1990-92
Goldsmiths College, London, MA Fine Art (Jane
and Louise)

1996
DAAD Scholarship, Berlin - Hannover, Germany

1999
Nominated for the Turner Prize

Jane and Louise Wilson live and work in London

SELECTED TWO-PERSON EXHIBITIONS

2004
'Erewhon', 303 Gallery, New York
'Jane and Louise Wilson', Bergen Kunstmuseum,
Norway
'Jane and Louise Wilson', Fondazione Davide
Halevim, Milan
'Jane and Louise Wilson', Bildmuseet, Umea,
Sweden
'A Free and Anonymous Monument', Pori Art
Museum, Pori, Finland
'Jane and Louise Wilson', De Appel, Amsterdam
(exhibition catalogue)

2003
'A Free and Anonymous Monument', Baltic
Centre for Contemporary Art, Gateshead
(exhibition catalogue)
'Jane and Louise Wilson', Lisson Gallery,
London

2002
Kunst-Werke, Berlin

2000
'Star City' and 'Proton, Unity, Energy,
Blizzard', 303 Gallery, New York
'Parliament', Bernier / Eliades, Athens
'Las Vegas; Graveyard Time', Dallas Museum
of Art

1999
'Turner Prize', Tate Gallery, London
'Stasi City', Hamburger Kunsthalle, Hamburg
'Jane and Louise Wilson", Serpentine Gallery,
London (exhibition catalogue)
'Gamma', Lisson Gallery, London

1998
'Stasi City', 303 Gallery, New York

1997
'Stasi City', Kunstverein Hannover (Touring
to Kunstraum Munich; Centre d'Art
Contemporain, Geneva; Kunst-Werke, Berlin)
(exhibition catalogue)

1995
'Normapaths', Chisenhale Gallery, London
(exhibition catalogue)
'Crawl Space', Milch Gallery, London

SELECTED GROUP EXHIBITIONS

2004
'Printemps du Septembre', Toulouse, France
(exhibition catalogue)
'Private / Public', 2nd Auckland Triennial,
New Zealand (exhibition catalogue)

2003
'Remind', Kunsthaus Bregenz, Austria
'Moving Pictures', Guggenheim Bilbao, Spain
'New Acquisitions', MOMA, New York

2002
'B. Open', Baltic Centre for Contemporary Art,
Gateshead (exhibition catalogue)

2001
'Public Offerings', LA MOCA, Los Angeles
(exhibition catalogue)

2000
'Vision and Reality', Louisiana Museum of
Modern Art, Humelbaek, Denmark
'media city seoul', Seoul Metropolitan Museum
(exhibition catalogue)
'Annika von Hausswolf, Jane and Louise Wilson
and Weegee', Magasin 3, Konsthall, Stockholm
'Film / Video Works - Lisson Gallery at
9 Keane Street', Lisson Gallery, London
'Dream Machines', curated by Susan Hiller,
Dundee Contemporary Arts, touring to Mappin
Art Gallery, Sheffield and Camden Arts Centre
'Age of Influence: Reflections in the mirror
of American Culture', MCA Chicago

1999
'Carnegie International: CI:99', Carnegie
Museum, Pittsburgh (exhibition catalogue)
'Seeing Time: Selections from the Pamela and
Richard Kramlich Collection of Media Art',
San Francisco Museum of Modern Art

1998
'Mise en Scène', Grazer Kunstverein, Austria
(exhibition catalogue)

1997
'Hyperamnesiac Fabulations', The Power Plant,
Toronto (exhibition catalogue)
'Pictura Britannica', Museum of Contemporary
Art, Sydney (touring to Art Gallery South
Australia, Adelaide; City Gallery, Wellington,
New Zealand)

1996
'NowHere', Louisiana Museum of Modern Art,
Humlebaek, Denmark (exhibition catalogue)
'Quatros Duplos', Fundaçao Calouste
Gulbenkian, Lisbon (exhibition catalogue)
'Full House', Kunstmuseum Wolfsburg, Germany
(exhibition catalogue)

1995
'The British Art Show 4', National Touring
Exhibitions; Edinburgh, Manchester, Cardiff
(exhibition catalogue)
'General Release', British Council selection
for Venice Biennale, Scuola di San Pasquale,
Venice (exhibition catalogue)
'Wild Walls', Stedelijk Museum, Amsterdam
(exhibition catalogue)

93

BOOKS AND CATALOGUES

2004
'A Free and Anonymous Monument', essay by
Giuliana Bruno, interview by Mary Horlock
(exhibition catalogue)
'Jane and Louise Wilson', De Appel, essays
by Barry Barker and Robbert Roos (exhibition
catalogue)

2000
'Jane and Louise Wilson', essays by Jeremy
Millar and Claire Doherty, Film and Video
Umbrella/ellipsis
'Public Offerings', LA MOCA, Los Angeles
(exhibition catalogue)
'media city seoul 2000', Seoul Metropolitan
Museum (exhibition catalogue)

1999
'Jane and Louise Wilson', Serpentine
Gallery, London, texts by Peter Schjeldahl,
dialogue with Lisa Corrin and Jane and
Louise Wilson (exhibition catalogue)
'Carnegie International: CI:99', Carnegie
Museum, Pittsburgh (exhibition catalogue)

1997
'Stasi City', Kunstverein Hannover (exhibition
catalogue)

1996
'NowHere', Louisiana Museum, Humlebaek,
Denmark (exhibition catalogue)

1995
'Normapaths', Chisenhale Gallery, London,
text by Cherry Smyth (exhibition catalogue)
'General Release', British Council selection
for Venice Biennale, Scuola di San Pasquale,
Venice (exhibition catalogue)
'The British Art Show 4', National Touring
Exhibitions, Arts Council and Hayward
Gallery, (exhibition catalogue)
'Wild Walls', Stedelijk Museum, Amsterdam
(exhibition catalogue)

Picture Credits

Front cover:
Fab Unit 2 2003
c-type print on aluminium in
perspex
120 x 120 x 5 cm

p.9
image: Cummins Engine Company

p.13
image: Gateshead Car Park
image: Cummins Engine Company

p.16
image: Atmel

p.18
image: oil rig

p.21
images: oil rig

p.25
image: Atmel

p.56
*Platform I, Gorilla VI - A
Free and Anonymous Monument*
2003
c-type print on aluminium in
perspex
180 x 180 x 5 cm

p. 59
Ballroom, Safe Light 2003
c-type print on aluminium in
perspex
180 x 180 x 5 cm

pp.60-61
Corridor, Safe Light 2003
c-type print on aluminium in
perspex
270 x 160 x 5 cm

p.63
Reflected Ballroom, Safe Light
2003
c-type print on aluminium in
perspex
180 x 180 x 5 cm

p.65
*Deck, Gorilla VI -A Free
and Anonymous Monument* 2003
c-type print on aluminium in
perspex
180 x 180 x 5 cm

p.66
Fab Unit 1 2003
c-type print on aluminium in
perspex
120 x 120 x 5 cm

p.68
Yellow Brick Road 2002
c-type print on aluminium in
perspex
180 x 180 x 5 cm

p.70
Fab Unit 3 2003
c-type print on aluminium in
perspex
120 x 120 x 5 cm

p.73
*View from Platform, Level I -
A Free and Anonymous
Monument* 2003
c-type print on aluminium in
perspex
180 x 180 x 5 cm

p.75
*View from Platform, Level II -
A Free and Anonymous
Monument* 2003
c-type print on aluminium in
perspex
180 x 180 x 5 cm

p.77
*Platform II, Gorilla VI -
A Free and Anonymous Monument*
2003
c-type print on aluminium in
perspex
180 x 180 x 5 cm

back cover:
Divided Ballroom, Safe Light
2003
c-type print on aluminium in
perspex
180 x 180 x 5 cm

A Free and Anonymous Monument

BALTIC Centre for Contemporary Art
13 September – 30 November 2003

A Free and Anonymous Monument was co-commissioned by BALTIC and Film and Video Umbrella.
Supported by Arts Council England, The Henry Moore Foundation and Film London.

Film Production:
Pinky Ghundale – Line Producer
Alistair Cameron – Cameraman
Jack Holmes – Camera Assistant
John Avery – Sound Recordist
Jon Stubbs – Grip
Geoff Scott – Spark
Reg Wrench – Editor

Production Team at Film and Video Umbrella:
Steven Bode – Director
Mike Jones – Technical Director
Caroline Smith – Administrative Director
Bevis Bowden – Production Co-ordinator
Nina Ernst – Projects Co-ordinator

Exhibition:
Pip Horne and Duncan McLeod – Installation Conception
Nick Joyce, Enigma FX – Installation Design and Realisation
Newlands – Screen Supply Co-ordination
Chris Brown at Atelier One – Structural Consultant
Complete Fabrications – Architectural Realisation
Lift Rite Engineering – Structural Works

Exhibition Team at BALTIC:
Stephen Snoddy – Director
Pippa Coles – Head of Programme
Nicola Hood – Assistant Curator
Chris Osborne – Technical Manager

Jane and Louise Wilson would like to thank:
For location assistance: Ross Forbes at Atmel; Cummins Engine Company; John Pasmore and the Apollo Pavilion, c/o District of Easington Council; Owen Luder Car Park c/o Gateshead Council; Jonathan Fairbanks, Bassoe Offshore, Houston and Terrie Sultan, Blaffer Gallery, Houston.

Nicholas Logsdail, Jill Silverman van Coenegrachts and Clare Coombes at Lisson Gallery, London; Lisa Spellman and Mari Spirito at 303 Gallery, New York; Eckhardt Schneider and Rudolf Sagmeister at Kunsthaus Bregenz; Janet Wilson, Louis Wilson, Zeyad Dajani.

Film and Video Umbrella would like to thank:
Gary Thomas and Marjorie Allthorpe-Guyton at Arts Council England; Maggie Ellis at Film London; David Metcalfe; Mark Lavender.

BALTIC would like to thank:
Sune Nordgren, Vicki Lewis, Tom Cullen and Sarah Martin for their significant contribution to this project; Esko Nummelin, Hannele Kolsio and Teija Lammi at Pori Art Museum, Pori, Finland.

Jane and Louise Wilson
A Free and Anonymous Monument

Published by Film and Video Umbrella, BALTIC Centre for Contemporary Art and Lisson Gallery, London, with support from Arts Council England, Film London and 303 Gallery, New York.

Edited by Steven Bode
Designed by Herman Lelie
Typesetting by Stefania Bonelli
Printed by Lecturis

© 2004: the artists and the authors
ISBN: 1-90427-011-5

Installation photographs: Jerry Hardman Jones and Colin Davison
Other photographic credits: Jane and Louise Wilson

film and video umbrella BALTIC LISSON GALLERY ARTS COUNCIL ENGLAND FILM LONDON The Henry Moore Foundation

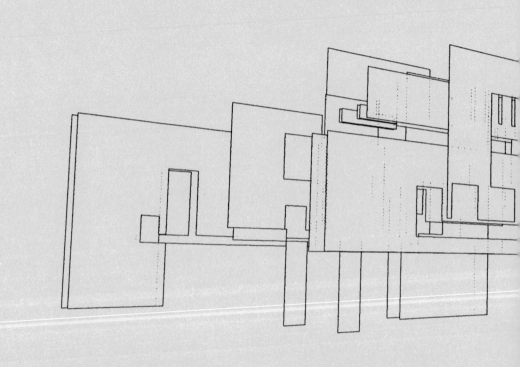